Claude Monet

Claude Monet 190

THE
GREAT
ARTISTS

Claude Monet

Ann Sumner

SIRIUS

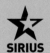
SIRIUS

This edition published in 2019 by Sirius Publishing, a division of
Arcturus Publishing Limited,
26/27 Bickels Yard, 151–153 Bermondsey Street,
London SE1 3HA

ISBN: 978-1-78950-718-8
AD006175UK

Printed in China

CONTENTS

INTRODUCTION

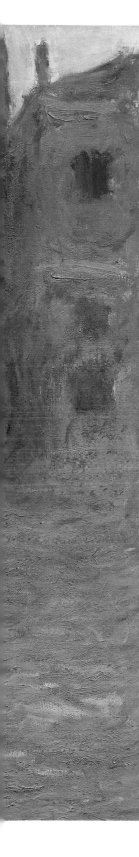

Today, Claude Monet (1840–1926) is globally recognized as a painter of colour and light, landscape and sea, rivers and bridges, architecture and parks, gardens and flowers, capturing ever-changing atmospheric conditions. His series paintings of poplars, haystacks, Rouen Cathedral and, ultimately, waterlilies saw him return to the same motif again and again, recording it at different times of day or season, and in contrasting weather conditions, whether bright sunlight, snow scenes or fog. Today, his paintings, especially those of his famous waterlilies, appear on coffee mugs, posters, tea shirts, bags and cards around the world, as well as adorning the front covers of hundreds of publications. These familiar images have helped turn Monet into a household name and arguably the most famous of the Impressionist artists. His paintings have been described by the British art critic Jonathan Jones as 'joyously accessible' and his work is represented in major museums and art galleries internationally. In 1889, he became the first Impressionist to enter the collection of an American museum when Erwin Davis, a wealthy mine owner, donated two of his paintings to the Metropolitan Museum of Art in New York. At the time, neither Monet nor any of the other Impressionists was represented in a French museum. American collectors were crucial to his success, such as Sarah Choate Sears of Boston and Potter and Bertha Palmer of Chicago, and there were early admirers of his art in Britain like the Davies sisters (Gwendoline and Margaret) in Wales, although generally the British were late to appreciate the Impressionists.

Venice, Palazzo Dario, 1908. Monet visited Venice late in his career and was particularly drawn to the brightly coloured marble façade of the Palazzo Dario on the Grand Canal.

The dealer Durand-Ruel struggled to enthuse the British about Impressionism during his major exhibition at the Grafton Galleries in 1905, yet today exhibitions of Monet's work are overwhelmingly popular with the public internationally. To accommodate interest from visitors, they often have to stay open for extended hours to enable audiences to view his paintings first-hand, to see his true colour range and the painted surfaces of his canvases, not merely to observe his images in endless reproduction. In more recent years, the Art Institute of Chicago's 1995 exhibition drew 965,000 visitors in 18 weeks, and during a 16-week period in 2010–11 more than 900,000 visitors flocked to the Grand Palais on the Champs-Élysées in Paris to view the exhibition *Claude Monet (1840–1926)*.

Curators are constantly thinking of new themes for shows to interpret his rich and hugely prolific career in different ways. Over the last few years a number of exhibitions have shed new light on the artist, his working practices and broader interests: *Monet, the Seine and the Sea* at the National Gallery of Scotland; *The Unknown Monet: pastels and drawings* at the Royal Academy, London; *Monet the Collector* at the Musée Marmottan Monet, Paris; and *Monet and Architecture* at the National Gallery in London.

This book tells the story of Monet from his early beginnings through periods of financial hardship to worldwide fame and considerable wealth, how he ultimately managed his relationship with a number of dealers and the sheer complexity of his art as it evolved. By tracing his life and artistic development, it is possible to see the influences upon him as he matured into the famous artist we know and revere today.

CHAPTER 1
Context and Reputation

A hugely talented and versatile artist, Monet was raised in Le Havre, on the Normandy coast. Initially an artistic prodigy who flourished as a caricaturist, he was introduced to landscape painting in the open air by his mentor Eugène Boudin, and as a result went to Paris to study art. After a brief period of military service in Algiers, he returned to France, and in 1862 he was enrolled at the Académie Atelier of the Swiss artist Charles Gleyre. During the Franco-Prussian War (1870–1), Monet spent a formative period in exile in London working with Pissarro, and met the dealer Paul Durand-Ruel, who would transform his career. He returned to France again, focusing on landscape painting, and in 1873 he began planning an exhibition with like-minded artists – Renoir, Pissarro, Degas, Sisley, Berthe Morisot and Cézanne. This was the group who became known as the Impressionists. They all shared an interest in subjects taken from modern life, a light and luminous palette, and the attentive study of the effects of light and atmosphere on people and landscapes. They were influenced by the older artist Édouard Manet too. Since their work had been consistently rejected for display at the official Salon, they took matters into their own hands, and the first independent Impressionist exhibition opened in 1874.

Impression, Sunrise, *1872. Monet painted the harbour at Le Havre, where he was raised, contrasting the dark, small boats on the water in the centre against the bright-orange rising sun in a blue-grey sky. The sun's shimmering reflection in the water below is surrounded by the workings of a harbour at dawn. The painting caught the eye of the critic Louis Leroy, who mocked the title at the First Impressionist Exhibition, 'since I was impressed there had to be some impression in it'. From this sarcastic comment, the term 'Impressionism' was born.*

Monet's house and garden at Giverny receives more than half a million visitors every year.

Monet has been described as the 'ultimate Impressionist', the 'Prince of Impressionism', the 'head of the school' and the Impressionist who stayed true to the idea of capturing light in all its fleeting sensations. At that first exhibition in 1874, his painting – *Impression, Sunrise* (1872), showing the harbour at Le Havre – caught the eye of the critic Louis Leroy, who mocked the title, but it was from this potentially bad press that the term 'Impressionism' originated, so familiar to us all now and defining an artistic movement.

Although Monet painted many bright sunlit views of the Normandy coast and the dappled sunlight in suburban gardens or views of the River Seine, it is his studies of waterlilies for which he is probably best known. He painted these in his garden at Giverny and they were a source of prolonged inspiration for him. Monet settled there in 1883, purchasing the house and land in 1890. Today, these waterlily paintings, some with the Japanese-inspired bridge, are extraordinarily familiar to us. His house and garden at Giverny are visited by more than half a million tourists each year, and are especially busy in the summer months.

In Monet's day there were constant visitors too, one of the first being the painter Gustave Caillebotte, his friend and patron. Later, other visitors included friends such as the writer Octave Mirbeau (who would often write his catalogue entries), artists who admired his work – from Bonnard to Singer Sargent – and the politician Georges Clemenceau, whom he had known since the 1860s.

Monet's personal life was somewhat complex and unconventional at times. He initially had to conceal his relationship with his first wife Camille from his disapproving family, and the exact timing of the beginning of his relationship with his beloved second wife Alice, widow of department-store magnate and art collector Ernest Hoschedé, is unclear. They lived openly together with their blended families at Vétheuil, Poissy and later at Giverny, although she was still married to Hoschedé. Her husband died in 1891, and Alice finally married Monet in 1892. His letters to her offer a remarkable insight into their relationship, and often his struggles with his artistic practice.

Blessed with a long life, his successful career spanned 60 years of painting, from the realism of the 1860s via the heights of Impressionism in the 1880s and '90s to his evolving, increasingly abstract painting of waterlilies in the early twentieth century. This longevity meant that he was able to exert a strong influence over his official biography, public image and legacy, perpetuating myths about his working methods and his use of drawings. Monet's work has always been associated with painting *en plein air* (in the open air) and it is true that he himself encouraged the notion that his art was 'impulsive, unrehearsed creativity', but it is now accepted that the complexity of his canvas surfaces, with intricate layers of paint and coloured highlights, suggests many were begun in front of

The Water-Lily Pond, 1899. Monet produced a total of 17 works based on this view of the Japanese-style bridge that spans the water-lily pond. The glorious use of colour recreates the waterlilies and other plants surrounding the pond in full bloom and the reflections of willows in the water.

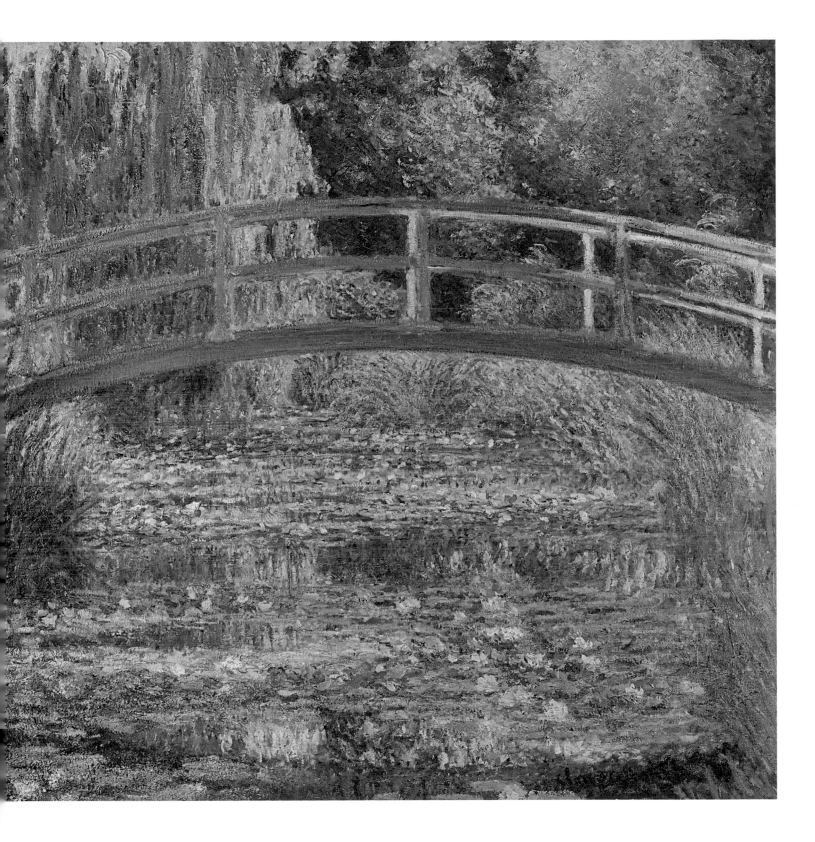

Nymphéas, *1918. A
preparatory sketch for one of
Monet's waterlily paintings.*

Waterloo Bridge, *1901.
Monet loved London's fog
and captured this hazy
impression of the famous
bridge on the Thames in the
entirely appropriate medium
of pastel.*

the image but finished in the studio while maintaining the appearance of being rapidly and spontaneously painted outside. Not only does examination of the paint surfaces of his pictures suggest this; so too do the documented recollections of contemporaries. Monet also denied the role of draughtsmanship in his art, and sold very few drawings in his lifetime, but his approach to this medium has been revised as well. His early caricatures demonstrate his technical ability and it is now accepted that he had a structured working method, employing preparatory drawings mid-career, and that he also worked in pastel – producing some striking examples in this medium of the cliffs at Étretat, dating from the 1880s, and a group of pastels of London's bridges in fog from 1901. Sketchbooks in the Musée Marmottan even contain studies directly related to his later waterlily paintings at Giverny. They may be somewhat sketchy and abstract but were clearly important as part of the design process.

Monet attained major fame in his own lifetime, not only in France but worldwide, most especially in America and Japan. He was an artist with an acute sense of business, understanding the importance of cultivating numerous dealers and patrons, and of putting on one-man shows. In later life he was a collector of art himself, owning the work of his teacher Boudin and paintings by Delacroix, Corot, Jongkind, Manet, Renoir,

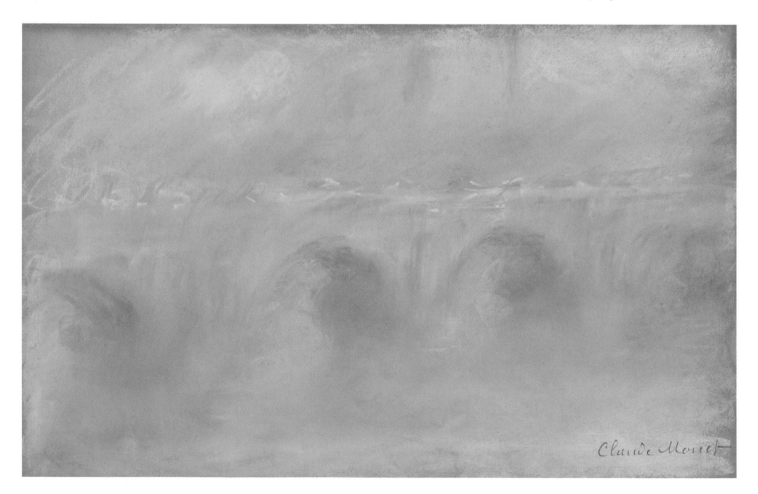

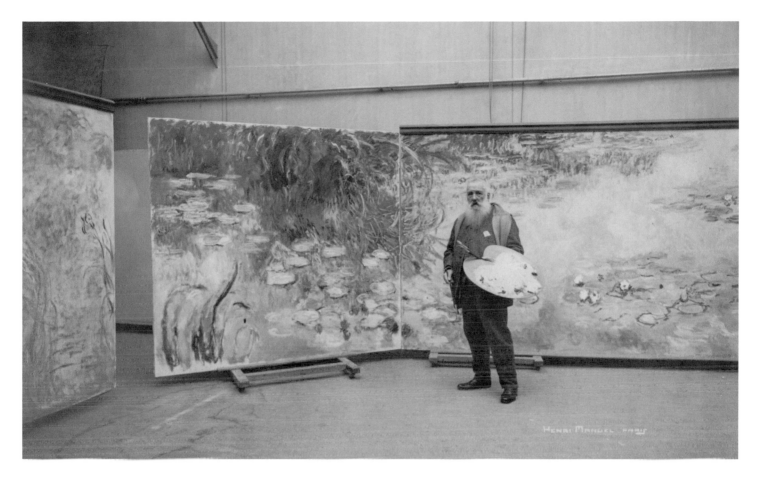

Henri Manuel's photograph of Monet, with easel in hand, standing in front of his paintings The Waterlilies, in his studio at Giverny, 1920.

Pissarro, Cézanne and Signac. He also brought together a collection of Japanese prints by Kitagawa Utamaro, Katsushika Hokusai and Ando Hiroshige, openly acknowledging his debt to Japanese art, most especially in the bold manner in which these artists cropped their subjects. The collection hung in the private apartments upstairs at Giverny, and was rarely shown to the many visitors, who included dealers, artists (especially young Americans), collectors (including a number of Japanese, such as Takeko Kuroki and Kōjirō Matsukata) plus a steady stream of journalists coming to see the great man. Monet only occasionally gave interviews in his later years, increasing the aura around him. His wealth was by that time conspicuous too – as one visitor recalled, he was 'surrounded by every comfort'. He employed a chauffeur and had a number of smart cars – which he enjoyed driving fast – and his wider staff included a butler, a cook and six gardeners to tend his water gardens.

In old age, Monet famously suffered from problems with his eyesight, an appalling condition for any artist, and underwent painful and debilitating cataract operations. Despite this setback and the loss of loved ones in later life, he produced some of his most remarkable waterlily paintings as World War I raged about him, and ultimately he donated his final great waterlily series to the French nation as a war memorial. When his dear friend Renoir died in 1919, he grieved greatly. He wrote to his friend the critic Geffroy, 'It's very hard. There's only me left, the sole survivor of the group.' He was the last living Impressionist, dying eventually in 1926, aged 86.

Claude Monet Reading
a Newspaper, *Pierre-
Auguste Renoir,
1872. Monet was not
interested in producing
self-portraits, but seems
happy to have posed for
a number of works by
his friends.*

The Young Artist

EARLY YEARS AND INFLUENCES IN LE HAVRE

Monet's formative years are crucial to understanding how he developed as a key artist in the Impressionist movement. Normandy, where he grew up, was important to him throughout his life and his family's support was vital to his early career. The coastal towns of Normandy had been transformed by the advent of the railways into popular tourist destinations, where artists also flourished. Both Eugène Boudin and Johan Barthold Jongkind worked there and exercised influence over Monet in his early career. His training in the studio of Charles Gleyre was also key because it was there that he met Frédéric Bazille, Alfred Sisley and Pierre-Auguste Renoir, all talented young artists with whom he would work closely. Monet is typically seen as a painter of landscape and yet as his style developed during this formative period, he was much preoccupied with painting figures in landscape too.

Oscar-Claude Monet was born in Paris on 14 November 1840, the second son of Adolphe and Louise Justine Monet of 45 rue Laffitte. Both his parents' families had been established for two generations in Paris. While we know the artist as Claude, he was called Oscar by his family. There is little information about his father's early career except that he was a shopkeeper. The entire family, including his father's parents, relocated to Le Havre on the Normandy coast of north-western France, around 1845. His father's half-sister, Marie-Jeanne Lecadre, was already established there, married to a successful wholesale grocer and supplier for ships. Monet's father joined his brother-in-law's retail business and prospered. The family settled in the Ingouville suburb of Le Havre, at 30 rue d'Epremenil, a large house where they initially took in lodgers. The nephew of one lodger recorded sometime later the life of the Monet household when he visited in 1853, explaining that he stayed with 'Monsieur Monet, his wife, who had an exceptional voice, and their two sons, the second of whom, though then called Oscar, was to attain fame as Claude Monet'. He described his short holiday: 'there were walks and seabathing' and 'in the evening improvised concerts and balls; everyone came together and brought the house alive with laughter.'

Caricature of Auguste Vacquerie, c. 1859. *This caricature demonstrates Monet's early drawing style, showing him carefully using dark graphite lines to define the eyes of his subject.*

Le Havre was flourishing and expanding at the time, and the Monet family summered at their aunt's holiday home at Sainte-Adresse.

At school, Monet's artistic talent for drawing was noted and encouraged by a teacher, Jacques-François Ochard, who had been a pupil of Jacques-Louis David. By the mid 1850s, when he was around 15 years old, Monet was producing skilled graphite caricatures of well-known figures in Le Havre. One early accomplished work unmistakably shows the French journalist and writer Auguste Vacquerie, an admirer of Victor Hugo. These early caricatures are all signed O. Monet.

In 1857, Monet's mother died and he was taken under the wing of his aunt Marie-Jeanne, who was an amateur painter herself and knew the artist Armand Gautier. She nurtured his talent and he began to sell his caricatures, with their distorted heads and diminished bodies, at a local stationer's shop, Gravier's. There, they were displayed near the paintings of Boudin, and were noticed by the Honfleur artist, who encouraged Monet to paint landscapes in the open air. He was soon taking his first sketching trip with his new mentor, Boudin finding inspiration in the coastline, beaches, shipping and harbours of Normandy, and painting in the open air. Monet learnt much from Boudin about tonal values, atmosphere and perspective, but crucially too how to sketch in the

View at Rouelles, 1858. Rouelles lies to the north-east of Le Havre and this work (one of Monet's earliest) was produced after a sketching trip with Eugène Boudin to the area.

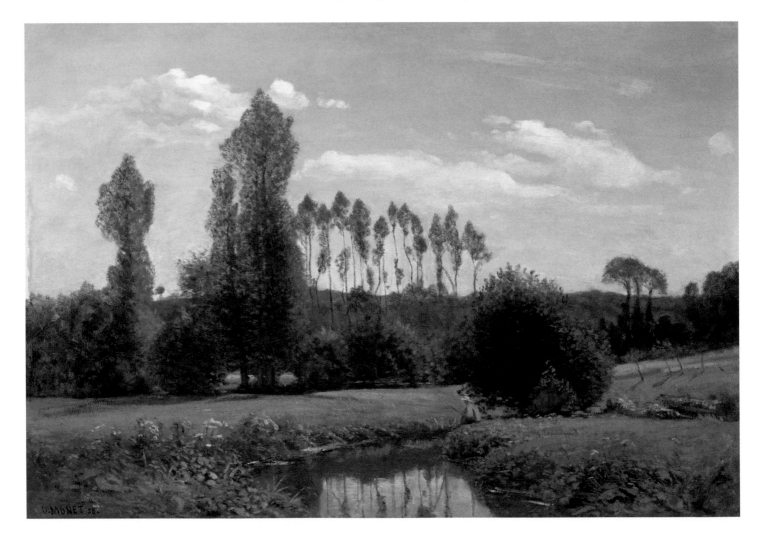

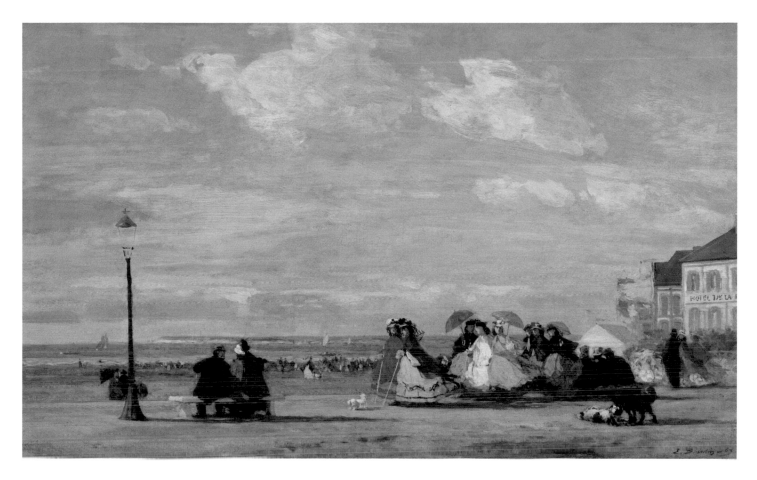

The Beach at
Trouville – The
Empress Eugénie,
*Eugène Boudin,
1863. Boudin painted
many views of the
beach at Trouville
that depicted the
fashionable visitors to
the Normandy coast.*

open air. One of his first paintings, reflecting the influence of Boudin, is *View at Rouelles*, which was exhibited in the Le Havre municipal exhibition in September 1858. The two artists wrote regularly to each other and Boudin continued to be his mentor. Later in life, Monet recalled, 'It was as if a veil had suddenly been torn away; I had understood, I had grasped what painting could be.'

Monet still continued with his caricatures, demonstrating a remarkable talent for human observation and a taste for mild satire. The notary Léon Manchon was depicted wickedly against a background of humorous posters – 'Notary, for marrying thereof. Payment facilitated. Immediate entry to pleasures guaranteed.' He also captured a group of visiting actors in 1859. Monet later recalled of this practice:

'I started selling my portraits. Sizing up my customer, I charged ten or twenty francs a caricature, and it worked like a charm. Within a month my clientele had doubled. Had I gone on like that I'd be a millionaire today. Soon I was looked up to in the town, I was "somebody". In the shop window of the one and only framemaker who could eke out a livelihood in Le Havre, my caricatures were impudently displayed, five or six abreast, in beaded frames or behind glass like very fine works of art, and when I saw troops of bystanders gazing at them in admiration, pointing at them and crying "Why, that's so-and-so!", I was just bursting with pride.'

Caricature of Léon Manchon, *c. 1858. Monet uses white chalk to emphasize the way the light falls on the face of his subject. Notices in the background proclaim Léon Manchon's occupation as a notary.*

horrible . . . the fact is there are simply no seascape painters and you could go far in that line.' He did admire Gautier's *Sisters of Charity* and took the opportunity to meet that artist in person, having an introduction through his aunt. At the Salon he had been disappointed by Delacroix but admired the Barbizon School painter Constant Troyon, though finding his shadows a little too black. He decided to visit Troyon too, who gave him some sound career advice – 'Start off by entering a studio where they do nothing but figurative work, studies from the nude: learn to draw . . . but do not neglect painting.'

By 1860 Monet had signed up to the Académie Suisse, supported by his father, where he met Camille Pissarro, a future Impressionist and friend. However, in March 1861, he was called up for military service and by June he was with a cavalry regiment serving his country in Algeria. The following summer, having fallen ill with typhoid fever, he returned to France to convalesce. While recovering with his family in Le Havre, he met another key influence on his career, the Dutch artist Johan Barthold Jongkind, whose work he had observed at the Paris Salon. Often seen as a precursor of Impressionism, Jongkind was interested in capturing atmosphere and the fleeting effect of light with feathery brushstrokes. Monet later acknowledged the impact Jongkind had had on his art: 'It was he who completed the education of my eye.'

Monet was finally discharged from the army in November, his aunt Jeanne Lecadre buying him out, for 3,000 francs, to allow him to continue to develop his artistic career. By the end of the year he had recovered sufficiently to enrol at the Charles Gleyre's Académie Atelier. The budding artists

THE EXPERIENCE OF PARIS AND NEW INFLUENCES

In May 1859 Monet visited Paris to view the Salon, the major annual French official art exhibition held at the Palais de l'Industrie. This annual event was a vast, well-attended survey of contemporary art sponsored by the French government and the first visit for Monet was a formative experience. The young man was disappointed by the seascapes he saw, writing to Boudin on 3 June, 'There is not one halfway decent seascape to be seen. Isabey's is

began their studies with drawing classes, which they had to master before moving on to the use of colour. Gleyre would later single out Monet as one of the students he spent most time with, describing him as charming.

In May 1863, the young artists must have been aware of the sensation caused by Édouard Manet's *Le déjeuner sur l'herbe* at the newly opened Salon des Refusés, which gave those whose submissions had been rejected by the official Salon jury the

opportunity to display their entries at the Palais de l'Industrie. Later that month, Monet and Bazille worked together painting landscapes in Chailly near the forest of Fontainebleau, where the Barbizon School of painters had found inspiration for their Realism style. Bazille wrote home to his mother: 'I have spent eight days at the little village of Chailly near the forest of Fontainebleau. I was with my friend Monet, from Le Havre, who is rather good at landscapes. He gave me some tips

Étretat, Johan Barthold Jongkind, 1865. While Boudin taught the young Monet much about composition, the Dutch painter Jongkind used a looser brush style that also influenced him.

that have helped me a lot.' Monet and Bazille enjoyed a particularly close friendship and often worked together during these early years. Bazille was from a wealthy Montpellier family and his parents were initially keen that he concentrate on his medical studies as well as his art. After spending the summer in Le Havre, Monet returned to Paris in the autumn.

Over the bitter winter of 1863–4, Gleyre suffered ill health, and it became increasingly clear that his studio was in financial difficulties. In May 1864 Monet left the establishment, closely followed by Renoir, Bazille and Sisley, and it closed in July. Monet departed for Honfleur for the summer and was soon writing, on 13 July, to persuade Bazille to join him. In this correspondence he revealed his youthful enthusiasm for his art and the inspiration the Normandy coast gave him:

> 'What on earth can you be doing in Paris, in such marvellous weather, for I suppose it must be just as fine down there? It's simply fantastic here, my friend, and each day I find something even more beautiful than the day before. It's enough to drive one crazy. Damn it man, come on the sixteenth. Get packing and come here for a fortnight. You'd be far better off; it can't be all that easy to work in Paris.'

Bazille had already visited Honfleur with Monet in March, and now, having failed his medical exams, he was dedicating himself to art. Monet remained at Honfleur, writing to Bazille and explaining in August that 'Jongkind and Boudin are here and we get on extremely well and stick together. . . . I'm sorry that you are not here, since there is a good deal to learn from such company.' As well as landscapes, Monet was painting still-life studies. He told Bazille that he was sending 'my flower picture to the Rouen exhibition, there are some really lovely flowers about at this time',

but the work was not reviewed in the autumn and failed to sell. Monet's finances were now causing him concern.

He eventually returned to Paris, and in January 1865 accepted an offer from Bazille to share a studio at 6 rue de Furstenberg, which would save him money and allow the two artists to feed off their shared creativity. Monet worked hard now to submit his first paintings to the Salon. Using drawings and sketches made on the spot, he worked up the large-scale piece *La Pointe de la Hève at Low Tide*. As yet, Monet was not painting all his works *en plein air* but adopting the more traditional approach of on-the-spot sketches and drawings which informed the final large-scale work for exhibition. The figures and horses on the beach, all observed from the rear, appear in other works painted by him during the 1860s. Presumably, he had drawings of such details to which he could refer when adding figures to his scenes. Such methods were, of course, completely opposed to his dedication to the tenets of Impressionism in the later 1860s, when he took up the challenge of making paintings entirely *en plein air*.

In March, Monet met and soon started living with a 19-year-old from Lyon, Camille Doncieux, who eventually became the model for his Salon submission the following year, as well as his first wife. In April, Monet and Bazille escaped again to Chailly, near Barbizon, for a further planned sketching trip, but Monet fell on arrival and hurt his leg. Bazille captures the young artist recovering in bed in an intimate portrait that reflects the depth of their attachment, and gives an informal glimpse of Monet's appearance at this time.

EARLY SUCCESS AT THE SALON

On their return the Salon opened, and Monet's two submissions, the products of his successful expedition to the Normandy coast the previous summer and autumn, were singled out for attention in the *Gazette des Beaux-Arts* and elsewhere. 'A new name must be mentioned,' wrote the *Gazette*

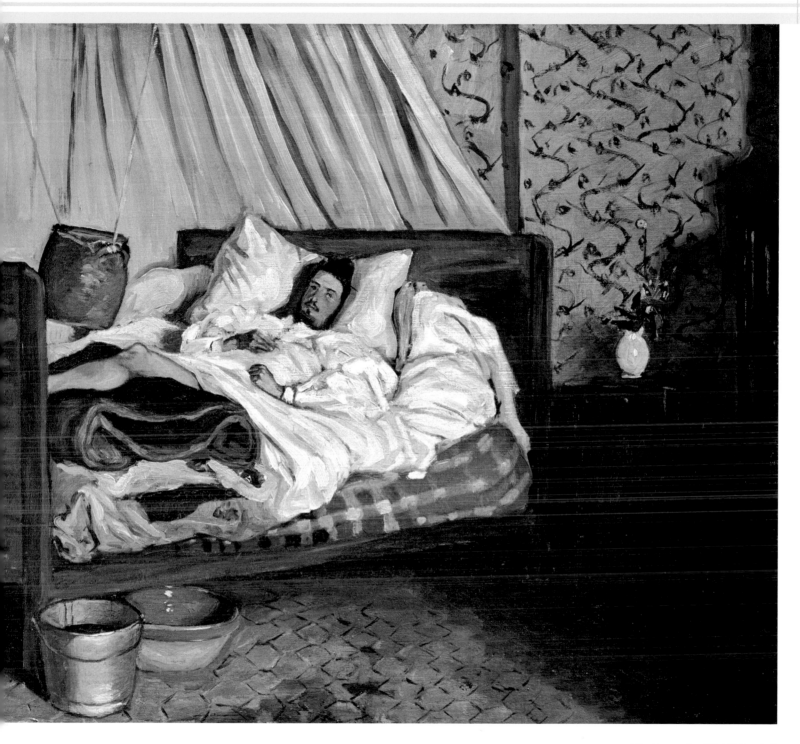

critic, 'Monsieur Monet, the painter of *La Pointe de la Hève at Low Tide* and *Mouth of the Seine at Honfleur*, was hitherto unknown. These works constitute his debut – but they lack that finesse which comes with long study.' However, the critic added that his 'notable overall character, his daring way of seeing and of enforcing our attention – all these are advantages which Monsieur Monet already possesses in a high degree. Henceforth we shall be following the work of this upright painter of the sea with great interest.' The dark and foreboding painting of *La Pointe de la Hève* shows his masterly observation of cloud formations and the effect of a shaft of sunlight. At the Salon, some viewers confused Monet's signature with that of the more established and controversial

The Improvised Field Hospital (L'ambulance improvisée), *Jean Frédéric Bazille, 1865. Bazille captures his friend Monet in bed with an injury following a fall. Monet had been making open-air studies for his* Le déjeuner sur l'herbe *since the spring when Bazille came to join him. This portrait captures Monet's despondency at being unable to paint.*

Édouard Manet. When the older artist received compliments for a painting that he had not painted, he was initially irritated, although later when he met Monet, a new friendship and rich artistic dialogue resulted.

Monet was already preparing for the next Salon in 1866. He wanted to be more ambitious and he emulated Manet by attempting to produce his own *Le déjeuner sur l'herbe*, following Manet's work of 1863. His canvas would be large-scale (4.20 × 6.50 m [13¾ × 21½ ft]) to attract attention and painted out in the open in the Barbizon Forest. It included up to 12 figures shown in the dappled light of the forest, enjoying a picnic of stuffed fowl, pies, wine and fruit, with no controversial nudity as included by Manet. Camille, now established as

his partner, and Bazille patiently posed for each of the figures. However, when Monet returned to the studio he found that the process of transferring the sketches to the larger format was more complex than he had imagined and he feared he would not finish in time. Indeed, the work remained incomplete. He had one landscape ready to submit, *Le Pavé de Chailly*, but still wanted to follow up his early success at the Salon with a work that had impact.

He abandoned his first idea and with little time to spare began a full-length portrait of Camille. Against a plain background, she is seen from behind, enabling the green silk of her bustle to be fully admired even as she looks over her shoulder, dressed in a fur-trimmed coat and hat, ready to walk out. Legend has it that it was completed in

La Pointe de la Hève at Low Tide, 1865. This atmospheric beach scene helped to launch Monet's arrival on the art scene when it was shown at the Paris Salon in 1865.

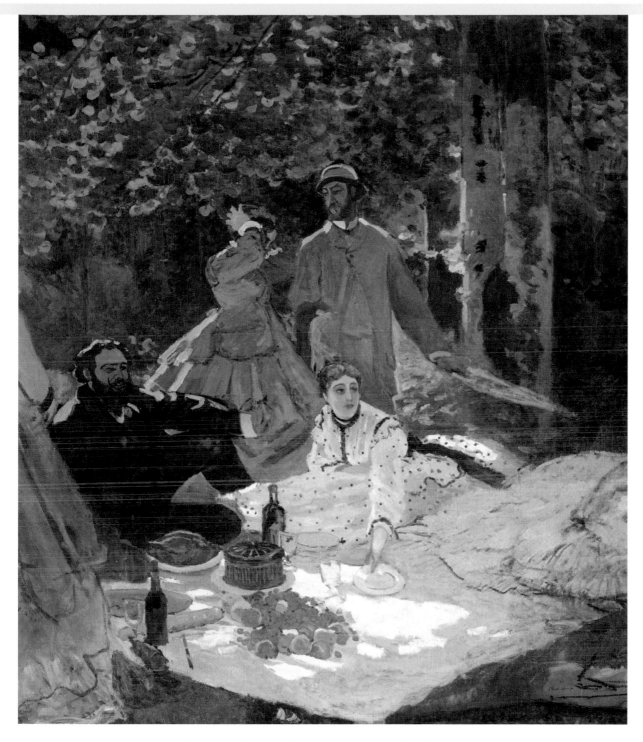

only four days, although the degree of finish makes this seem unlikely. The approach is very traditional in the rendering of the silk and fur, and yet there is realism in the painting of a thoroughly modern young woman, who appears to be moving across the canvas, glancing back across her shoulder as she adjusts her hat. Monet submitted this portrait of *Camille* (*The Woman in the Green Dress*) and it made a major impact at the 1866 Salon, attracting remarkably positive reviews and acclaim.

While some critics referenced the Old Masters, Émile Zola picked up on the modernity of the painting: 'I confess that the picture which longest detained me was the *Camille* by M. Monet. . . . Just consider that dress. It is both supple and firm. Softly it

Le déjeuner sur l'herbe *(central surviving panel), 1865. Close study of this work shows the unfinished state in which Monet abandoned it.*

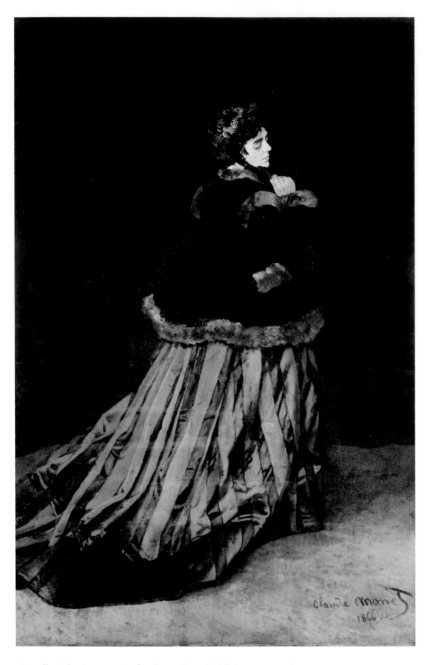

Camille (The Woman in the Green Dress), *1866.*
With its dark background and realistic style,
this portrait of Camille Doncieux shows great
attention to textural detail in the treatment of the
stiff satin of the skirt and the fur trim of her jacket.

drags, it is alive, it tells us quite clearly something about this woman. It is not a doll's dress, the muslin dreams are wrapped in: this is a fine, real silk, really being worn.' Most importantly for Monet, the work sold for 800 francs to the writer Arsène Houssaye, and several further paintings sold as a result of this success.

Only two fragments now survive of Monet's *Le déjeuner sur l'herbe*. Much later, in 1920, he explained the fate of the painting: 'I had to pay my rent, I gave it to the landlord as security and he rolled it up and put it in the cellar. When I finally had enough money to get it back, as you can see, it had gone mouldy.' When he finally claimed it back in 1884, he cut it up, and kept only three fragments. The third has now disappeared.

Not wanting to be defeated by the challenge of depicting figures successfully in a landscape on a large scale, Monet began *Women in the Garden* as his submission for the Salon of 1867. He removed himself to the Parisian suburb of Sèvres, renting lodgings in the Ville d'Avray. There in the garden he dug a trench in the ground to allow him to paint on this vast canvas in the open air. Camille was his model again and he used magazine illustrations to ensure that he captured the latest fashions. A craze for gardening had taken off in the Paris suburbs, where patches of garden were filled with abundant flowers. The women he portrayed here are picking bouquets of roses and gladioli and the central figure shades her face with a parasol. Their almost life-size images are dressed in large, bright white dresses reflecting the dazzling sunlight, with dramatic contrasting shaded areas in the shelter of the tree. This work was not finished in Sèvres, but the vast canvas was transferred to Honfleur that summer, where it remained for part of the winter while Monet continued to refine it. The painter Alexandre-Louis Dubourg observed this and described it in a letter to Boudin of 2 February 1867: 'Monet is still here, working away at enormous pictures . . . he has one which is nearly three metres high and just as wide. The figures are

slightly less than life-size, women in full summer dresses picking flowers in a garden. It's a canvas that he started in the open air.'

FAMILY DISAGREEMENTS AND FINANCIAL CONCERNS

As spring advanced, Monet returned to Paris, now sharing a studio with Bazille and Renoir at 20 rue Visconti. He waited to hear if his *Women in the Garden*, in which he had invested so much, would be selected for the Salon, but while the composition may have been significantly more successful than *Le déjeuner sur l'herbe* of the previous year, and completed well in time, it was rejected. Finished in the studio, the painting was refused by the jury of the 1867 Salon because of the lack of subject and narrative, and the visible brushstrokes which seemed to be a sign of carelessness and incompleteness. One of the members of the jury declared: 'Too many young people think of nothing but continuing in this abominable direction. It is high time to protect them and save art!'

Camille was at this stage pregnant and Monet was facing financial hardship, so his devoted friend Bazille stepped in, paying him 2,500 francs for the painting – a large sum for a little-known artist. He paid Monet in monthly instalments of 50 francs. Monet's family did not approve of Camille and he was forced to leave her in Paris while he returned to his aunt and father in Normandy to gain financial assistance. He spent the summer of 1867 at his aunt's country house at Sainte-Adresse, writing to Bazille asking him to care for Camille, who gave birth to their first child Jean in Paris on 8 August. Meanwhile, Monet was working on a number of seascape and garden compositions, encouraged by his family. One in particular, the *Garden at Sainte-Adresse* (see page 27) seems to be a precursor to Impressionism, with its representation of bright sunlight, fluttering flags, colourful flowers – vivid yellow and red gladioli, geraniums and nasturtiums – and a deep-blue sea with distant shipping and foreground figures sitting in chairs and holding

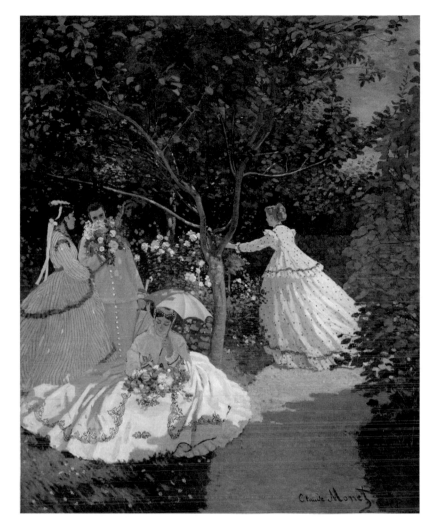

Women in the Garden, *1866–7. Monet uses a technique called* peinture claire *in this work to emphasize colour areas, in particular the effect of light and shade. The lack of subtle tonal colouring together with no immediate perception of a 'story' gave the Salon jury enough reasons to reject it in 1867.*

parasols. These figures were members of his family – his father is seated there wearing a panama – although this is not actually his aunt's villa, which had no direct view of the sea. The artist exhibited it 12 years later in the Fourth Impressionist Exhibition.

Monet's situation remained tense and unresolved for the next couple of years. Although briefly in Paris with Camille during the winter, and painting

for a period at Bougival (on the left bank of the Seine between Chatou and Port-Marly), Monet was soon forced to leave again. Back in the Le Havre area, he painted seascapes in preparation for the 1868 Salon submissions. By the late spring of 1868, he was reunited with Camille and his son Jean, working at Bonnières-sur-Seine, and in May one of his paintings – *Boats Coming out of the Port of Le Havre* (now lost) – was accepted for the Salon while another was rejected. Over the summer, he showed five paintings

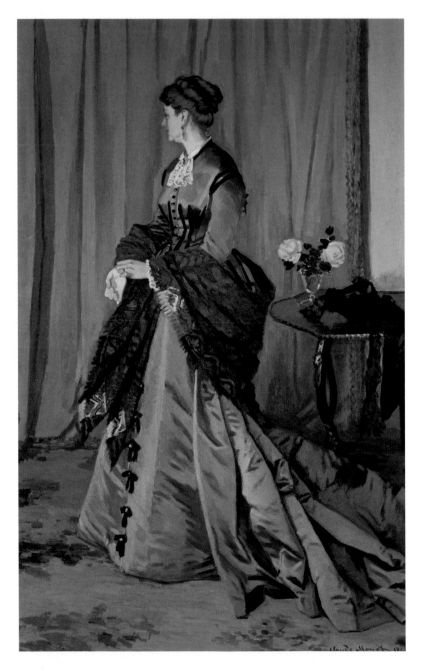

at Le Havre in the International Maritime Exhibition, where he was awarded a silver medal, his original art teacher Ochard being on the exhibition jury. In August 1868 Camille and Jean finally moved to Fécamp to be with him, discreetly away from the Monet family who were unaware of her presence.

Finances remained a real concern, but Monet did receive an important portrait commission to paint Madame Gaudibert, the wife of a local wealthy ship owner, Louis-Joachim Gaudibert, who also purchased some of his paintings from the Maritime Exhibition. The elegant, full-length portrait of Madame Gaudibert illustrates how versatile Monet was and how accomplished at capturing the details and textures of her dress, the green silk and black velvet bows. The sitter's face is actually turned away from the viewer, as she hugs her rich woven red shawl about her.

Monet was happily settled during the winter of 1868–9 in Étretat, with his mistress and son, writing in December to Bazille, 'Here I am surrounded by everything I love. In the evening my dear friend, I come back to my little house where there is a good fire and a good little family. If you could only see your godson, how sweet he is at present.' During this period, he painted the stormy winter sea at Étretat – a location where he would continually find inspiration in the future – bringing to life the crashing, foaming waves. He also completed a number of subtle snowscapes, including perhaps his best known snow scene *The Magpie*, which depicts the countryside near Étretat in deep snow. Executed on the spot, this work employs pale, luminous colours, reflecting the sunlight and shadows on the new snow, which may explain why it was rejected by the jury of the Salon the following year.

Madame Louis-Joachim Gaudibert, 1868. *In her fashionable dress with its elegant bustle and draped with a fine shawl, Madame Gaudibert is the epitome of the wealthy merchant's wife. This sumptuous portrait gave Monet the opportunity to demonstrate his ability to capture the subtleties of textile drapery.*

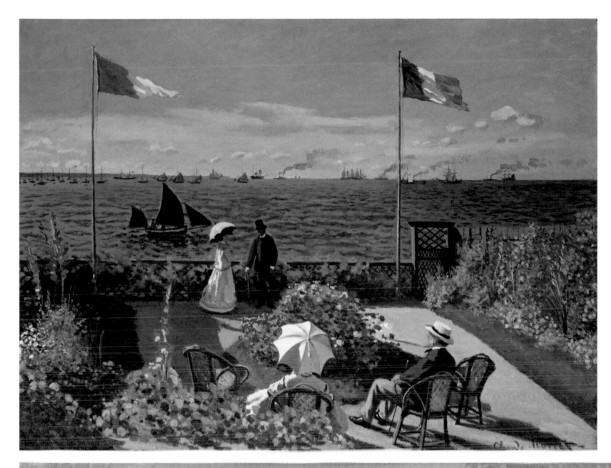

Garden at Sainte-Adresse, *1867.*
Although the figures seem quite stiffly posed, the fluttering flags and the steam of the passing ships in the background give the impression of a summer breeze.

The Magpie, *1869.*
Following in the footsteps of one of his mentors, Gustave Courbet, who had also painted snow scenes, Monet perfectly conveyed the luminescent snow and the shadows cast by the fencing.

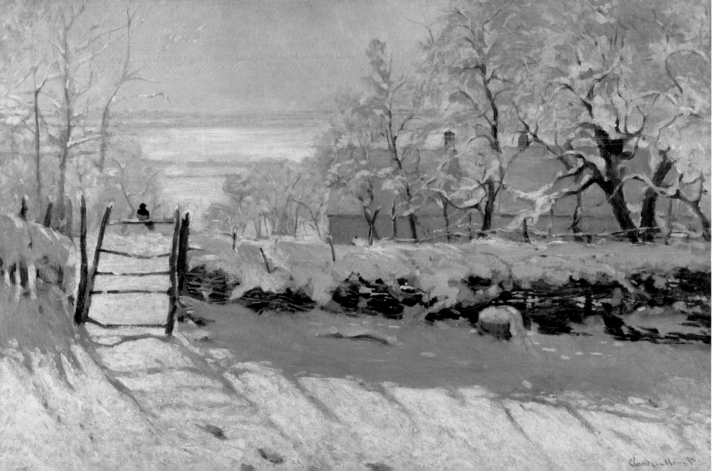

LA GRENOUILLÈRE AND WORKING WITH FRIENDS

In early 1869, Monet determined that he would have to relocate to Paris again. He settled at Bougival with Camille and Jean in the summer of 1869 and worked closely with Renoir. Together they painted side by side with their easels, depicting the bathing pool and floating café at La Grenouillère (The Frog Pool), a perfect spot for observing contemporary life. Two on-the-spot sketches with exceptionally free handling of paint by Monet survive, capturing the reflections in the river and the bathers in their long black suits enjoying the sunshine, with moored boats in the foreground. They appear to have informed a third painting finished in the studio (a larger-sized painting, now lost but formerly in the Arnhold

Collection in Berlin, is known from a black-and-white photograph). Monet and Renoir worked so closely together that their style is almost indistinguishable. Renoir's surviving painting is perhaps livelier, with feathery brushstrokes and more tightly framed, while Monet's is the less structured. In these works, Monet anticipates the style that would be referred to as Impressionism from 1874 onwards.

The young artists continued to work companionably together. One painting shows the emerging young artists working closely in Bazille's studio at this time. This studio, in the rue de la Condamine, was shared by Bazille and Renoir until 15 May 1870. Bazille, a tall figure with his

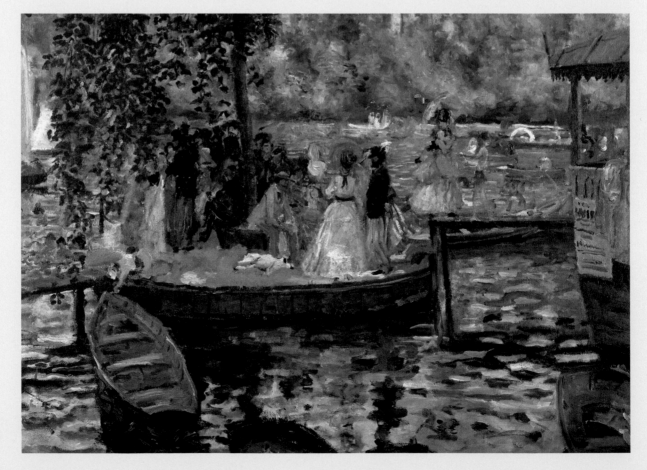

La Grenouillère, *Pierre-Auguste Renoir, 1869. Renoir's figures are more detailed as he focuses on the floating island which is more crowded, the women in their white summer dresses, the sleeping dog, the cascading tree providing shade with more boating activity beyond on the Seine than Monet captures.*

palette, is depicted centrally in black. However, as he wrote in a letter to his father, 'Manet painted me in.' Manet himself is portrayed wearing a hat, carefully considering the canvas on the easel. At the piano is Edmond Maître, a friend of Bazille, playing. Above him, a still life by Monet is a reminder that Bazille so often tried to assist Monet during this early period by buying his work. Possibly Monet and Renoir are shown on or by the stairs. This is a relaxed snapshot of the young artists with Manet, the artist for whom they all had so much respect, influencing and shaping their stylistic development.

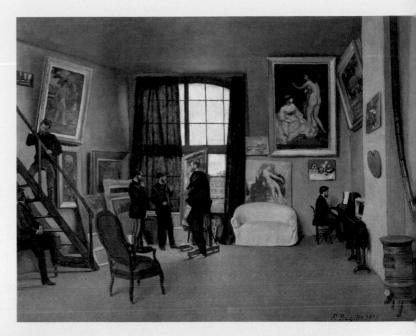

La Grenouillère, 1869. *Monet's approach is fresh and direct with free handling of paint, capturing the gathering of bathers enjoying the sunshine and the Seine on the floating island, less than in Renoir's work with bathers cooling off in the river to the left.*

Bazille's Studio, Edouard Manet, 1870. *Monet is possibly to the left of the painting.*

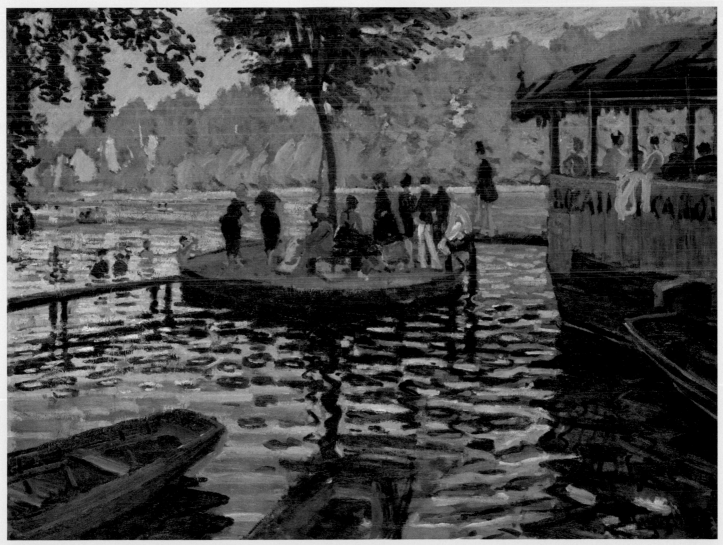

MARRIAGE, WAR AND EXILE IN LONDON

Monet's two 1870 Salon submissions, *Luncheon* and *La Grenouillère*, were rejected, while Bazille, Renoir and Pissarro all had works accepted. Although demoralized, Monet had other thoughts on his mind; it had become clear that war might break out between Prussia and France. On 28 June, Monet and Camille were finally married in Paris. The painter Gustave Courbet was one of the witnesses. Just a few days later, on 7 July, Monet's beloved aunt, who had done so much to nurture his career, died at Sainte-Adresse.

Monet and Camille spent the rest of the summer on honeymoon in the fashionable Normandy resort of Trouville. There, he was inspired to paint a group of energetic key works, which demonstrate his developing style. Some are reminiscent of his mentor Boudin, who visited the young couple during this period. Showing the beach and holiday makers promenading, they capture the tourists enjoying the sunshine under shifting clouds and blue skies. One is quite distinctive and original – a vibrant depiction of *Hôtel des roches noires*. Named because of the seaweed-covered rocks nearby, it was a renowned hotel with 150 rooms and a concert hall. Monet captures it in a vertical format, representing the façade at the side of the canvas, concentrating on the terrace, where figures are walking and greeting each other, and the bright flags fluttering in the sea breeze against a vivid blue sky. Here, he catches the effects of light and the movement of wind, using especially loose brushstrokes in depicting the colourful striped flags.

Five paintings show Camille informally sitting on the beach at Trouville, which may perhaps have been a series of studies for a larger Salon painting Monet never completed. The best known is on display at the National Gallery, London. Here, the composition is again unusual, showing Camille shielding herself with a parasol, her face half shaded; an empty chair is central in the foreground and a further female figure in black, facing the viewer reading, is cropped. The paint surface has been analysed, which reveals it contains grains of sand, confirming the appearance that Monet painted it in situ on the beach.

On 19 July, France declared war on Prussia, and on 1 September the French army was defeated by the Prussians and their German allies. By mid-September, northern France was under occupation and Paris was under siege. Bazille had already enlisted in the 1st Zouave Regiment, Manet and Degas signed up to the National Guard in Paris, and Renoir was called up and posted to Bordeaux. Monet and Camille, however, were quick to find a ship across the English Channel with their young son, fleeing to England, as did Pissarro and his family. Monet had no intention of returning to the army and wanted to avoid conscription. By the first week in October, he and his family were safely in London, first in lodgings near Piccadilly Circus, then in Kensington. In November, he received the crushing news that his dear friend Bazille had been killed in a minor skirmish at Beaune-la-Rolande. He was just 28 years old. Monet spent seven

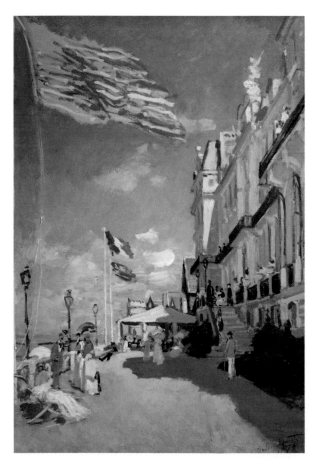

Hôtel des roches noires. Trouville, 1870. *Light and movement are key elements in this summer depiction of Trouville with its fashionable visitors greeting one another as they promenade.*

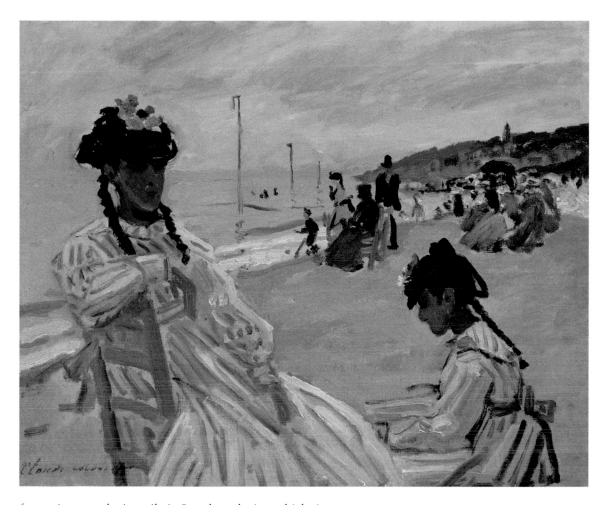

On the Beach at Trouville, 1870. *Monet did not attempt to reproduce the faces of his subjects here in great detail. His aim was to capture the moment and spontaneity of the scene before him.*

formative months in exile in London, during which time he painted five cityscapes, including two of parks and another two showing the Thames, these works being a considerable contrast to his light, joyous creations in Trouville on his extended honeymoon.

In England, French refugees were welcomed. Among them were the Barbizon painter Charles-François Daubigny, Léon Lhermitte, the sculptor Jules Dalou and the entrepreneurial art dealer Paul Durand-Ruel, who opened a gallery in New Bond Street. Daubigny had fled in early October and settled initially near Leicester Square. He worked mostly on French scenes while in London, except for his famous view of St Paul's Cathedral. Meeting Monet sketching by the Thames, he introduced him to Durand-Ruel in January 1871. Monet had brought some paintings with him from France and one, *Entrance to the Port of Trouville* (1870), was included by Durand-Ruel in the first exhibition of the Society of French Artists, organized in

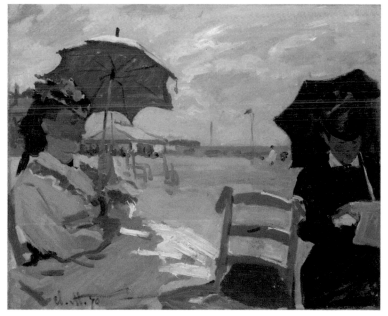

The Beach at Trouville, 1870. *Caught in an unguarded moment, Monet's wife Camille shades herself with a parasol, while her companion, possibly the wife of Eugène Boudin, reads a newspaper.*

December 1870. The relationship with Durand-Ruel became crucial for Monet's future success. In January 1871, Monet learnt of the death of his father, whose recent remarriage meant that there was no significant legacy for his son. Together with Pissarro, Monet took in the London museums; there, they encountered the art of Constable and Turner, which undoubtedly had some influence on their development.

Monet was working on a foggy scene of the new Houses of Parliament and the Embankment. The Parliament building had been rebuilt after a devastating fire and was completed only in 1870, along with the new Embankment, which is shown in the foreground with workmen dismantling the scaffolding. Monet employed broken and loose varied brushstrokes here, creating the atmospheric effect of fog on the distant building and bridge, with the emerging shipping in the middle distance. It was a scene that he would return to again at the turn of the century, in very different circumstances, to produce paintings that have become iconic. Durand-Ruel bought this early picture but not until November 1872. Eventually it was sold to Ernest

Hoschedé, the department-store magnate and art collector, in 1877 just before his bankruptcy. Another similar work shows the Thames near the Tower of London, including a view of the Customs House. Having been raised in the port of Le Havre, Monet was fascinated by shipping and here accurately depicts the rigging of the boats and the barges in the foreground. He also captured in an elongated format one of London's green spaces, Green Park. Under a gloomy sky, figures in dark clothing are strolling and taking the air.

Meanwhile, Monet's works were rejected by the Royal Academy, but were included in Durand-Ruel's Society of French Artists second exhibition, while three pieces were selected for an International Fine Art Exhibition, which opened in Kensington in May. Only one of the works was painted in England and that was *Repose* (now known as *Meditation, Madame Monet Sitting on a Sofa*), showing Camille in their apartment at 1 Bath Place, Kensington, sitting on a chaise longue. The work is sometimes felt to reflect the influence of Whistler, who was also working in London. None of the pieces exhibited attracted the attention of the critics

Green Park, London, 1870/71.
Visitors to one of London's central parks enjoy the open space as the buildings of the captial are seen in the distance behind them.

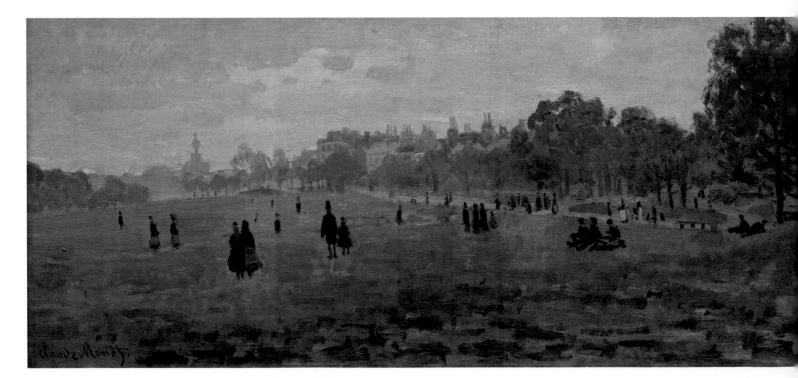

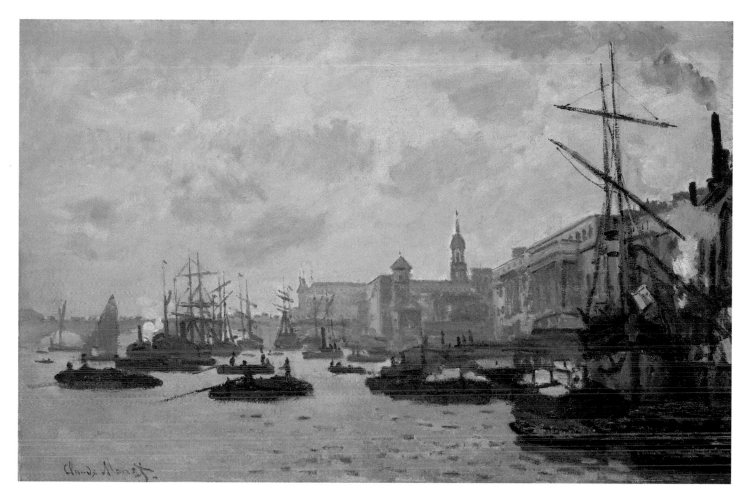

The Thames at London, *c. 1871. Monet was attracted by the shipping activities he witnessed on the river, here taking place in front of the Port of London building on the right-hand side.*

and, in fact, Monet sold no paintings at all during the nine months he was in London. By September, he had decided to leave and returned to France via Holland, where the stayed at Zaandam, north of Amsterdam. In November the Monets were back in Paris, and in December they rented a house in a suburb north-west of Paris called Argenteuil, on the River Seine. It was there that Monet and his fellow artists, with their shared interests and stylistic similarities, developed the style we know today as Impressionism.

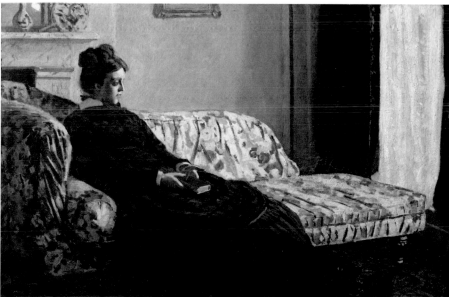

Meditation, Madame Monet Sitting on a Sofa, *c. 1871. Unable to speak English and without much to occupy her, Camille appears isolated and somewhat sad, and she may well have missed France during the couple's stay in London.*

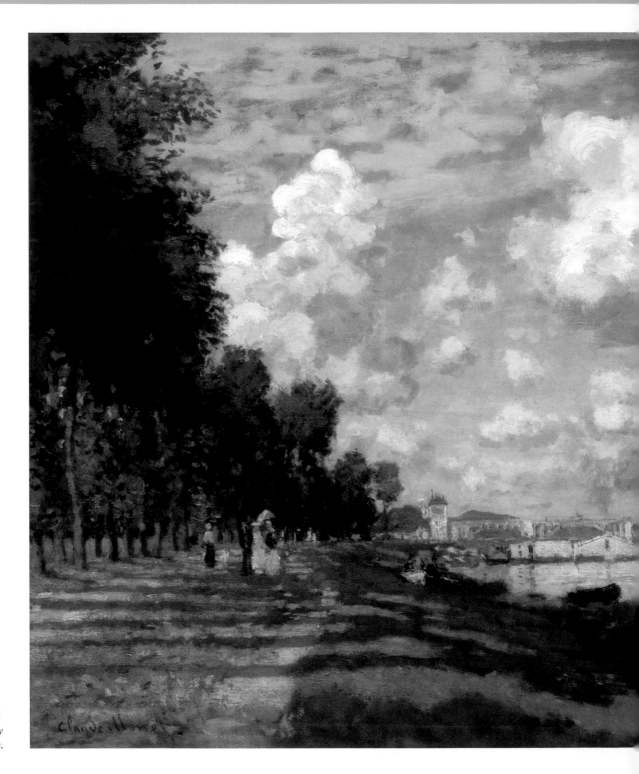

The Marina at Argenteuil, 1872. *Monet captures a brilliant blue sky filled with clouds above the boats on the river and the distant bridge, with relaxed figures picnicking on the bank and strolling on the path, crossed by the long shadows made by the trees in the afternoon sun.*

CHAPTER 3
Impressionism Takes Shape

ARGENTEUIL AND MONET

It was in Argenteuil, where Monet lived from December 1871 to January 1878, that the instantaneous nature of Impressionist art was developed – the idea of painting the fleeting moment, capturing the effects of light in the open air. The future Impressionists gathered around Monet – Sisley coming to visit immediately, Renoir and Manet (as well as Caillebotte, Pissarro, Degas and Cézanne) following – and the artists worked together, often painting side by side with a common purpose. Argenteuil was a major inspiration. It was located just 11 kilometres (7 miles) from the centre of Paris, a train journey of only 15 minutes. From the 1850s it was known for its sailing regattas and leisure activities on this attractive stretch of the River Seine. Although surrounded by rural fields, the town also had flourishing industries: four gypsum mines, a chemical plant, distilleries and tanneries. Monet captured the streets of the little town, the pleasure boats on the river and the bridges of the Seine, rebuilt after the damage of the Franco-Prussian War. This was one of the most prolific and fertile periods of his career. He also nurtured his fascination for painting suburban gardens, with Camille and young Jean or their visiting friends appearing amongst the flowers and foliage. These paintings reflect his interest in gardening, which he would develop further at Giverny, as well as his domestic happiness.

Some of his pictures painted at Argenteuil during the 1870s are still his best known and most popular today. His financial position began to improve too: Durand-Ruel purchased 29 works in 1872 and a further 25 in 1873. In that latter year, Monet had an income of 24,800 francs, twice what a doctor or lawyer in Paris might expect. Certainly, many of the pictures he produced in Argenteuil appear to reflect a comfortable middle-class life in the Parisian suburbs, as well as domestic tranquillity. On the whole Monet was careful with his money, but now he was confident enough to buy his painting supplies from one of the foremost houses in Paris and the excellent condition today of his art from this period reflects his sound investment in the working essentials.

THE INSPIRATION OF GARDENS AND FLOWERS

Monet was drawn to depicting images of his suburban garden in 1872, studying the lilac trees in the spring, first under grey skies when figures are almost hidden under the trees and then bathed in sunshine with the figures in light shadow. These paintings have been seen as precursors of his series paintings, which he developed 10 years later. *The Artist's House at Argenteuil* (1873) was painted in the garden of the Monets' first home in Argenteuil, which had a substantial garden of approximately 2,000 square metres (21,500 square feet). The work shows his young son, Jean, playing in the shadowed foreground with a hoop, surrounded by beautifully planted blue and white Chinese export pots, while the flower borders burst with colour and a tree is in full blossom. Camille watches over her son from the doorway of the house with its shutters and vine-covered walls. The garden has clearly been lovingly tended.

Lilacs, Grey Weather, *1872.*
One of two paintings of the same composition that Monet painted in his garden, this work is seen as the beginning of his obsession with studying the effect of the change of light on a scene.

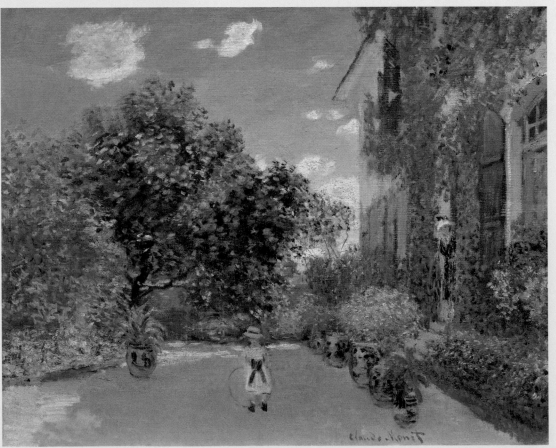

The Artist's House at
Argenteuil, *1873. Monet's son Jean can be seen playing with a hoop in the centre of this view of the family's home in Argenteuil. Camille Monet stands watching at the door.*

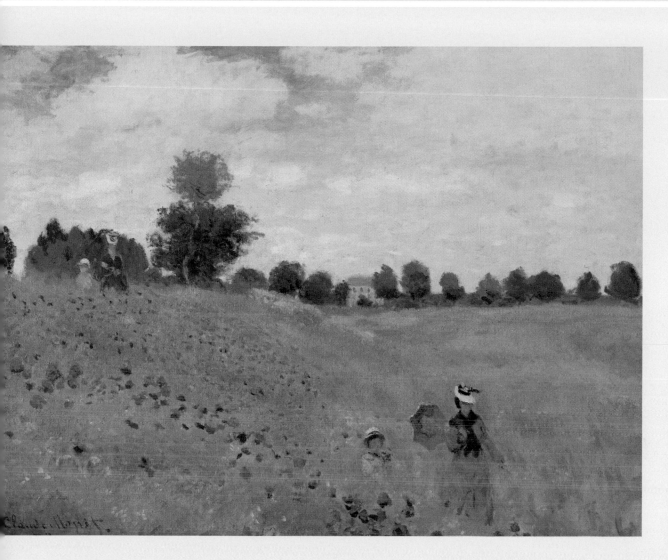

Poppy Field, 1873. Now one of Monet's most famous works, this dreamy image recreates a hot summer's day in the countryside around Argenteuil. The artist creates a strong diagonal line between the two pairs of figures.

Another work, *A Corner of the Garden with Dahlias* (1873), demonstrates the size of the garden and shows the three-storey shuttered house in the distance, and a couple emerging through the gate, while in the foreground a vast array of brightly coloured dahlias dominate. Monet's friend Renoir, also a keen gardener, captured him apparently painting this scene in *Monet Painting in his Garden at Argenteuil* (1873). It shows him with his palette in hand, his easel set up near the fence, as he contemplates the scene he is depicting. The array of houses in the distance testifies to the fact that this is a suburban scene; Monet is surrounded by other houses and their cultivated gardens. It calls into question whether the dahlias were actually his own or whether he was painting those of his neighbour.

Monet also loved the wild flowers in the fields around Argenteuil and one of his best known paintings of this period is *Poppy Field* (1873). The foreground of the painting is dominated by red poppies, rising up a bank, with a woman and child, undoubtedly Camille and Jean, walking through the long meadow grass in the summer sun. In the distance there are trees and a red-roofed house and in the middle distance splashes of yellow indicating more flowers. The brushwork is informal with loose red dabs of bright red paint representing the poppies emerging from the green grass. The small boy, wearing a hat, seems to hold a bunch he has picked and his mother, dressed in blue, lets her parasol fall to the side, suggesting that it is not the heat of midday. Here, Monet has captured the informal atmosphere of an idyllic French summer day in the countryside – an everyday scene, which undoubtedly contrasts with the official vision of the French landscape championed in the Paris Salon, where artists focused either on the spectacular scenery of coasts and hills or on the fertility of France's agricultural lands. It may not seem a revolutionary work to us today, but in 1870s France this was a new, modern subject matter in addition to a new style of painting.

The Promenade at Argenteuil, 1872. *This work has a serene quality, and illustrates a particularly tranquil stretch of river. In the background, the tall chimneys of the factories can be seen belching smoke out into the atmosphere.*

Monet was particularly attracted to painting the Seine at Argenteuil, as well as the surrounding rural landscape, and the income from the recent sale of paintings enabled him in 1874 to fit out a little boat as a floating studio, inspired by his friend Daubigny. During his six years at Argenteuil, Monet depicted the river on nearly 70 occasions. Sometimes he is clearly painting from the riverbank, capturing all the activity on the promenade as well as on the river, as in *The Marina at Argenteuil* (1872) with its distant view of the road bridge. The vast sky and white clouds on a sunny day are broadly painted, as the shadows from the trees fall across the grassy bank in the foreground. Such sailing boats and bridges would appear again and again in his works. The tree-lined promenade initially attracted his attention too, as illustrated in *The Promenade at Argenteuil*, a picture depicting springtime.

But Monet did not spend all his time at Argenteuil: he returned to Normandy, exhibiting in Rouen in 1872 and going back for inspiration to familiar territory in Le Havre, where he painted a number of works including the now iconic *Impression, Sunrise* (see page 6). This is a picture that does seem to have been painted in one continuous session, with broad, rapid brushstrokes. The dating of the work is slightly disputed. It was probably painted in 1873, but later dated 1872 by Monet. Whenever he actually painted it, he cannot have had any idea of the impact it would have and how well known it would later become.

Back in Argenteuil, in the autumn of 1873, he and his fellow future Impressionists began to discuss a group exhibition outside the official Salon, where they had struggled to find recognition.

Monet had enjoyed initial success but since then his works had often been rejected. At the end of December, the *Société anonyme des artistes peintres, sculpteurs et graveurs* was officially launched and began to formalize plans for their first exhibition, where visitors and potential patrons could see their work. It would also give them a platform to attract the attention of the critics. Initially, it was envisaged that each contributor would pay a subscription of 60 francs, entitling them to exhibit two works, but this restriction was not observed.

THE FIRST IMPRESSIONIST EXHIBITION, 1874

This long planned group exhibition – Bazille had first proposed an independent exhibition in 1867 – eventually opened in April 1874 at 35 Boulevard des Capucines in Paris, the former studio of the famous photographer Nadar (Gaspard-Félix Tournachon). Monet had been painting there that autumn and winter and included a street scene of 1873 in the show. In total, he contributed five oil paintings, including the now iconic *Poppy Field*, and seven pastels. Overall about 3,500 people saw the show.

For Monet the exhibition was key because he found

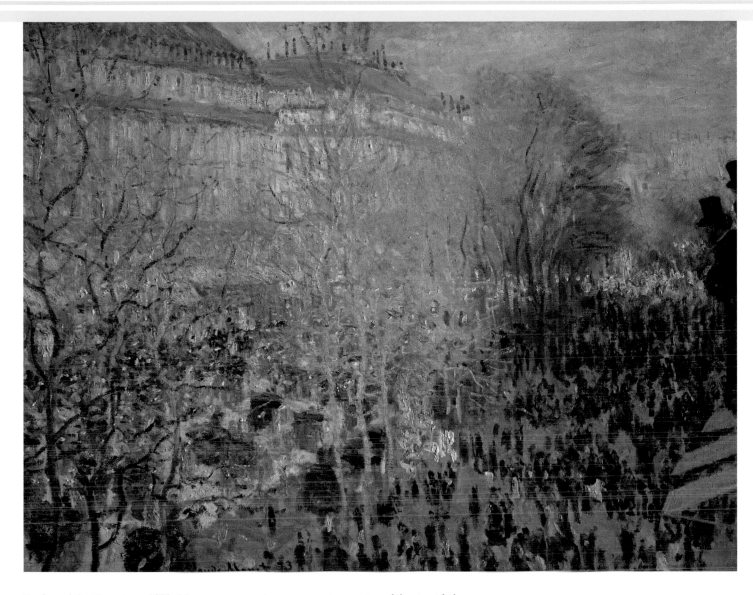

Boulevard des Capucines, 1873. Monet creates an instantaneous impression of the street below bustling with figures and carriages seen through the leafless branches in the autumn sunshine.

new patrons. He sold works to the opera singer Jean-Baptiste Faure and to Dr Georges de Bellio, both of whom would consistently purchase his work in the future. *Impression, Sunrise* was singled out by the critic Louis Leroy. Writing in the satirical journal *Le Charivari*, the printmaker and playwright ridiculed it, mocking the title and the stylistic approach: 'Wallpaper in its embryonic state is more finished than that seascape.' His article was called sarcastically 'The Exhibition of the Impressionists', and the term 'Impressionism' was born. All of Monet's oil paintings drew attention, *Boulevard des Capucines* being the most mentioned by the critics. Ernest Chesneau, a highly regarded critic writing in the *Paris Journal* in May, commented: 'Never has the prodigious animation of the

street, the antlike scurrying of the crowd on the pavement, the carriages on the roadway, the shimmering of the trees on the boulevard amid its dust and light, never before has the elusiveness of movement been caught and held in its fluidity as in this extraordinary *Boulevard des Capucines*.' Monet captured the dramatic, plunging view, looking down on the bustling street below from the second-floor window of the famous photographer's studio. The scene is bathed in autumn light with tree branches breaking up the building façades and the pavements crowded with pedestrians. Two gentlemen can just been seen in their top hats to the far right of the canvas, gazing out from an adjacent balcony over the shop awnings below. Chesneau was positive about the new emerging school of artists though he lamented the

inclusion of established artists such as Boudin, fearing that the public would be attracted to these more conventional works rather than those of the innovative younger artists. Other critics as well as Leroy used the word 'impression' in describing these works. For instance, Armand Silvestre, best known as a poet, thought Monet, Pissarro and Sisley sought 'nothing but the effect of an impression, leaving the search for expression to those devoted to line'. The critics were overall favourable and undoubtedly recognized the novelty of the Impressionists' style, their use of bright colour palettes and their depiction of light. Even so, while the exhibition raised their profile, it was not a financial success.

A CREATIVE SUMMER AT ARGENTEUIL

Returning to Argenteuil, Monet had a prolific summer, working again on the banks of the River Seine and painting the road bridge and the distinctive railway bridge from various different angles, perhaps best known in the dazzling *The Bridge at Argenteuil*, depicting the road bridge. Here Monet's energetic and vibrant brushstrokes capture the blue of the River Seine and the pleasure boats, reflecting the fleeting effect of sunlight. He also represented the railway bridge in the warm afternoon sunshine with a train rolling across it, steam belching into the air above while below a silent sailing boat heads between the vast white piers of the bridge.

The Bridge at Argenteuil, 1874. The strong, ordered composition of this work is reflected in the road bridge at the right of the painting and the distant toll house, while in the foreground the firm masts of the sailing boat form a vertical presence, with the blue sky brilliantly reflected in the river.

Renoir arrived that sunny summer month – July 1874 – and the two artists worked together painting the delights of the regatta season. (The Society of Parisian Regattas, the most prestigious sailing club in the region, was based in Argenteuil.) These regular events were a key part of the summer activities on the river and Monet had painted them before, in 1872. This time he chronicled the tall-masted boats hastily, the sketchiness hinting at the urgency with which he worked to capture a highly spontaneous moment in the race, the movement of the sailing boats with the wind in their sails. Renoir meanwhile painted a near-identical scene but with more boats and more substantial numbers of spectators lining the bank. Significantly, that summer, Manet also stayed nearby, at Gennevilliers, visiting his family and coming regularly to Argenteuil to work with Monet. The older artist, who had not participated in the First Impressionist Exhibition, was now inspired by his younger friend, and they embarked on a period of intensive creative activity together. Manet produced some of his best-known paintings, having absorbed these new Impressionist approaches, such as *The Seine at Argenteuil* and *Monet in his Studio Boat*.

Landscape: The Parc Monceau, 1876. *Situated on the boulevard de Courcelles in Paris, the park was designed in the English style and here Monet focuses on the lush lawns and blooming shrubs and trees.*

In October that year, the Monets moved to a second house in their adopted home Argenteuil, just opposite the station – a pink house with green shutters – and during the harsh winter that followed Monet painted no less than 18 snowscapes, including *Snow Scene at Argenteuil* (1875). This shows the boulevard Saint-Denis on which their pink house was located, which ran down towards the Seine. This atmospheric work conveys the bleakness of winter, as does another that portrays an incoming train at the station, *Train in the Snow* (1875). In early February 1876, Cézanne visited the Monets at Argenteuil and arrangements were soon being discussed for a second Impressionist exhibition – but Monet was now looking beyond Argenteuil for inspiration, to Paris and urban scenes.

View of the Tuileries Gardens, 1876. The high viewpoint of this picture suggests the artist is looking out of a window in the Louvre, a wing of which can be seen on the left.

THE CITY – A TOUCH OF REALISM

Early in 1876 preparations were underway for the Second Impressionist Exhibition, which opened on 30 March, mounted at Durand-Ruel's gallery at 11 rue Le Peletier in Paris. Gustave Caillebotte joined the ranks of the group, exhibiting eight works. He was independently wealthy and became a close friend of Monet, later supporting him with the offer of funds for works yet to be completed. Of the 252 works exhibited, Monet contributed 18 paintings, and two works by his great friend Bazille were also shown in tribute. Attendance figures were not as high as those for the previous exhibition, but there were more reviews, which were also slightly more favourable, and the group did manage to pay Durand-Ruel 3,000 francs to cover the rental of the gallery.

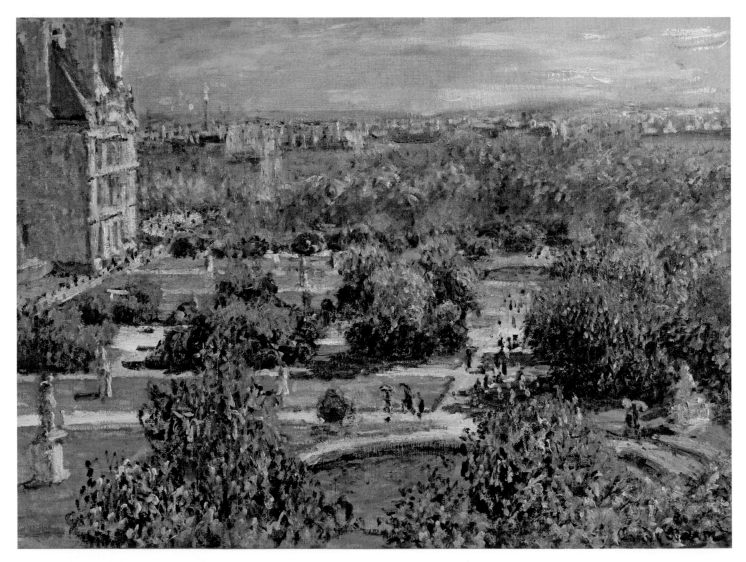

That spring and early summer, Monet found his inspiration in central Paris, especially concentrating on the parks. He captured three vivid springtime views of Parc Monceau, a popular park located on the boulevard de Courcelles in a fashionable area of Paris. He also painted four views of the Jardin de Tuileries from the apartment of the art collector Victor Chocquet at rue de Rivoli, observing Parisian society promenading and enjoying the spring weather. From July through to December, Monet painted in the south of Paris, working at the Chateau de Rottembourg, owned by Ernest Hoschedé and his wife Alice, also keen art collectors. Monet was commissioned by Hoschedé to paint large views for their chateau, including the garden with its roses and pond, and this was the moment, while her husband was away attending to his tangled financial arrangements, that he might well have grown especially close to Alice. Monet remained there for an extended period and did not return to Argenteuil until the end of the year, when financial concerns troubled him. Caillebotte came to his rescue, renting him a studio in Paris in January 1877, where he lived and worked until March, having easy access to Parisian patrons and being close to a station which inspired some of his best-known paintings.

Monet began work on an astonishing series of paintings of the Gare Saint-Lazare, a station built in the 1850s, from where trains ran to the Normandy coast and to Argenteuil, so he was entirely familiar with it. Seven of these paintings were exhibited at the Third Impressionist Exhibition in 1877, along with views of Parc Monceau and the Tuileries Gardens. In all, Monet contributed 30 works to this exhibition, of which 11 were on loan from Hoschedé, and Caillebotte paid the rent for the space just opposite Durand-Ruel's gallery. There were 8,000 visitors that year, and the series of the Gare Saint-Lazare attracted particular attention.

These iconic pictures and their reception at this Impressionist exhibition undoubtedly secured the artist's reputation. However, the financial ruin

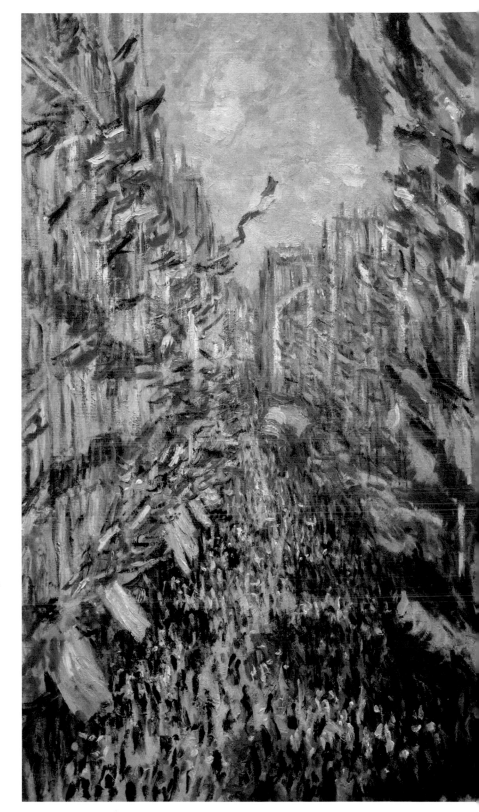

La rue Montorgueil à Paris. Fête du 30 Juin 1878, *1878. The atmosphere of this scene seems almost palpable, with the crowds milling around and the flags flying from every window in the street. The short, sharp brushstrokes add to the energetic quality of the work.*

of one of his key patrons, Hoschedé, in 1877 also contributed to his own financial difficulties. Although he was productive, Monet was not making enough money on the sale of individual works to meet his expenses. By January 1878, the Monets were forced to leave their Argenteuil home – and could barely afford the move. What's more, Camille was pregnant again and had been unwell for some time. Manet was among a number of friends who helped financially at this time.

The Monets returned to Paris and lived for a time at 26 rue d'Édimbourg, although Monet still had use of the studio near Gare Saint-Lazare for painting. They struggled to pay the medical bills following the birth of their second child and Monet continued to extend pleas for financial support to friends and patrons. That spring, he initially painted around the Isle of La Grande Jatte, on the Seine, which was not far from where they were living. The Exposition Universelle opened in Paris on 1 May to great excitement, and the Impressionists decided not to have their own exhibition that year, realizing that the focus of critics and the public would be elsewhere. In fact a group of their paintings sold at alarmingly low prices at the Hotel Drouot in late April. Following the bankruptcy of Hoschedé, another sale of his collection of Impressionists in early June was a spectacular failure also, although Monet's paintings sold for reasonable prices, including *Impression, Sunrise*, which went for 210 francs to the physician and art collector Dr Georges de Bellio.

Although times were hard, Monet produced one of his most exuberant pictures shortly afterwards – *La rue Montorgueil à Paris. Fête du 30 Juin 1878*. The Republic had decreed this date as a major celebration of France during the Exposition Universelle and citizens decorated their homes with flags and bunting, which the artist captured in rapid brushstrokes. Once again, Monet takes a high viewpoint, looking down on the celebrating crowds and mastering the distant vanishing perspective. This was a textile area of Paris and much bunting had been made to celebrate. Much later, in 1920, he explained to the art dealer René Gimpel how he came to paint this narrow street: 'I loved the flags. On the first 30th of June National Holiday, I was walking with my painting gear in the rue Montorgueil, the street was hung with flags and the crowd was crazy; I spotted a balcony, I went up and asked permission to paint, which was granted me. Later I came down incognito!' Somewhat confusingly, he also painted the rue Saint-Denis on the same day, flags flying, crowds celebrating and from another elevated position – and the two similar works have been confused. By early July he had sold the rue Montorgueil painting to Dr de Bellio to settle a debt and somewhat surprisingly, shortly afterwards, the recently bankrupt Hoschedé purchased the rue Saint-Denis version for 100 francs. Eager to create some much-needed income, Hoschedé had sold it on by August for 200 francs.

Rue Saint-Denis, Fête du 30 Juin 1878, *1878. Monet's second painting of the celebrations on 30 June is darker in tone but no less lively. He uses a stronger palette of colours, and by creating a triangular perspective as the street becomes narrower as it twists round to the right he leads the viewer's eye up to the centre of the image.*

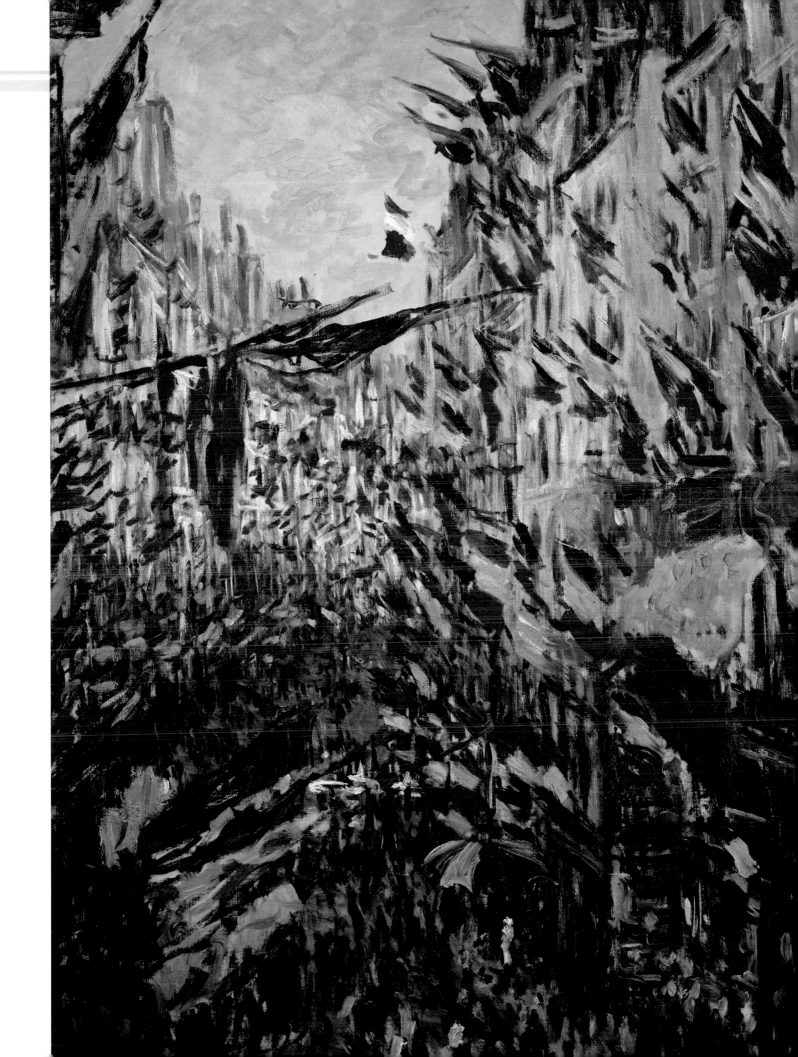

THE GARE SAINT-LAZARE

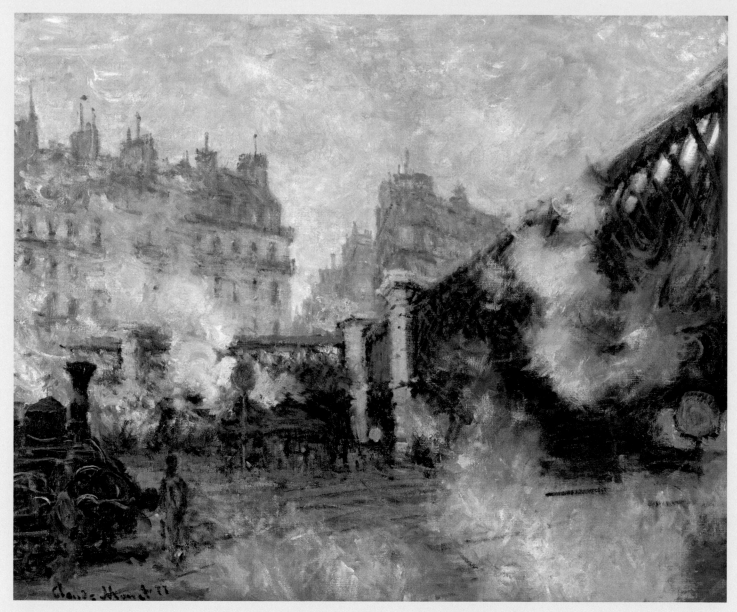

Le Pont de l'Europe, Gare Saint-Lazare, 1877. *The railway represented the increasing modernity that Monet's generation experienced and wished to convey in their work. The strong lines of the iron bridge separate the city buildings from the bustle of the large station below.*

Monet gained special permission from the authorities to paint at the Gare Saint-Lazare and planned his painting campaign with a number of preliminary drawings. In *La Gare Saint-Lazare (on the suburban side)*, he carefully works out the composition for one of the finished paintings but includes more background buildings here than he would later in the finished painting. Such sketches confirm the importance of drawing in his process, which he often sought to play down. In all, he painted 12 different views of this massive station, the largest in Paris, some being complete compositions and others more rapid in technique and sketch-like.

He captured the play of light and billowing steam from the locomotives underneath the great vault of the station (*La Gare Saint-Lazare* and *The Gare Saint-Lazare: Arrival*

of a train, the largest in the series), with passengers and railway staff going about their daily life on the platforms and tracks below. One atmospheric view, *Le Pont de l'Europe, Gare Saint-Lazare*, shows the famous Pont de l'Europe bridge: the mighty iron bridge, locomotives and shimmering steam stretch across the foreground while the Parisian architecture beyond gives an urban context to the scene. This contrasts with his views of the rural railway bridge at Argenteuil, being set in the heart of the city. In this series, he is portraying modern Paris and contemporary people in everyday settings.

Monet worked on all the paintings simultaneously, as he would later do on his series pictures, and on occasion he leaned the canvases against each other, leaving circular indentations from the cork spacers on the back of some works on the canvas surface of others – and this can still be observed today. With this series, his technique and paint handling developed, and these extraordinary paintings feature heavy impasto.

When they were shown at the Third Impressionist Exhibition in 1877, an anonymous journalist writing in *Le Rappel* in April noted that Monet had captured 'the spirit of this contemporary world in which forward momentum cannot be halted, driven as it is by the Locomotive'. 'Jacques' in *L'Homme libre* heaped praise on the paintings: 'His brush has expressed not only the movement, colour and activity, but the clamour; it is unbelievable. Yes, this station is full of din – grindings, whistle – that you can make out through the confusion of clouds of grey and blue smoke. It is a pictorial symphony.' And Émile Zola, the novelist, playwright and journalist, wrote in *Le Sémaphore de Marseille*: 'Monet has shown wonderful station interiors this year. You can hear the grinding of the trains entering them and see the clouds of smoke rolling under the vast roofs. This is where painting is today. . . . Our artists must find poetry in stations, as their fathers found it in forests and rivers.' Not everyone was favourable, however. In *Le Figaro*, Baron Grimm noted that Monet 'has in the last analysis, attempted to give us the disagreeable impression of several locomotives whistling all at once'.

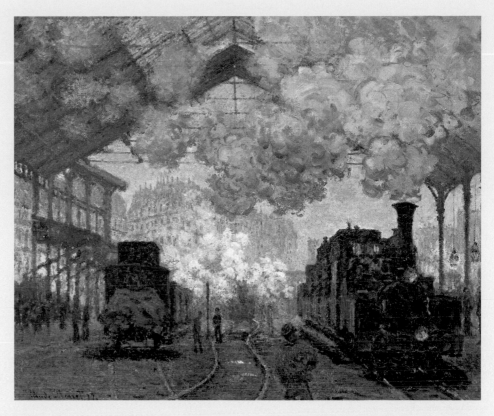

The Gare Saint-Lazare: Arrival of a train, *1877. Scenes such as this were typical of a day in the life of the station, but Monet brought home their dramatic message of industrialization and power.*

La Gare Saint-Lazare (on the suburban side), *1877. One of Monet's preparatory sketches for his series of paintings of the Gare Saint-Lazare.*

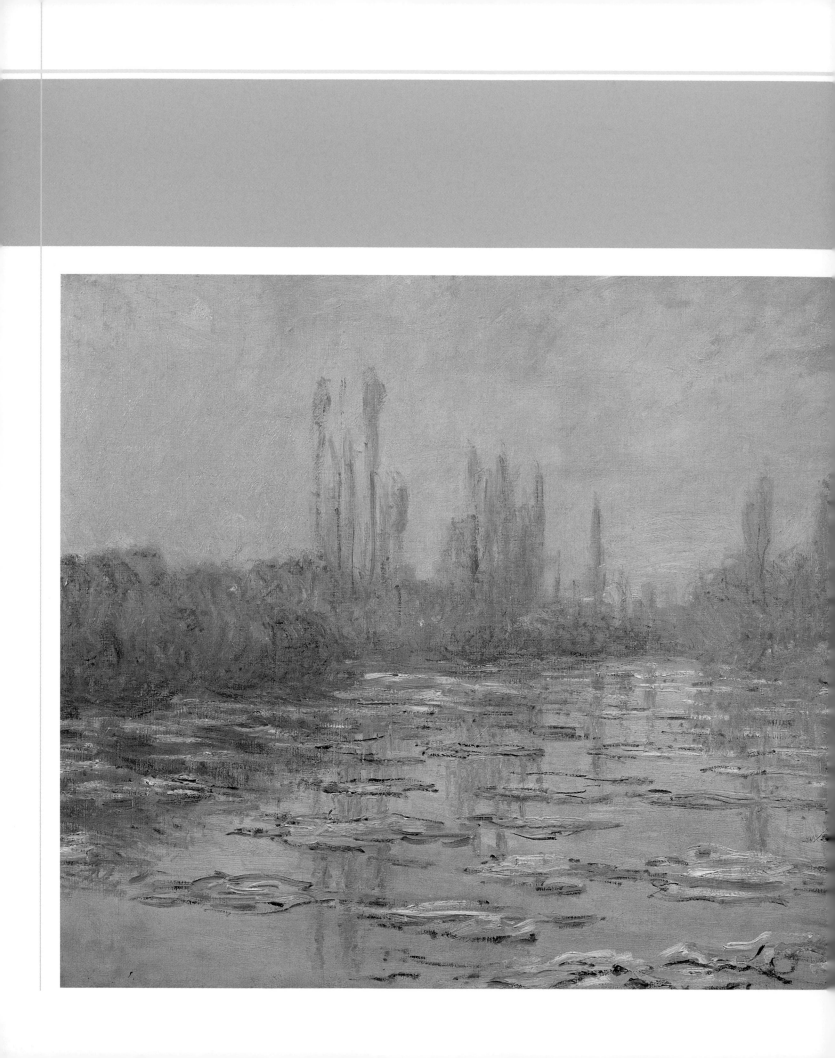

CHAPTER 4
Refining Impressionism

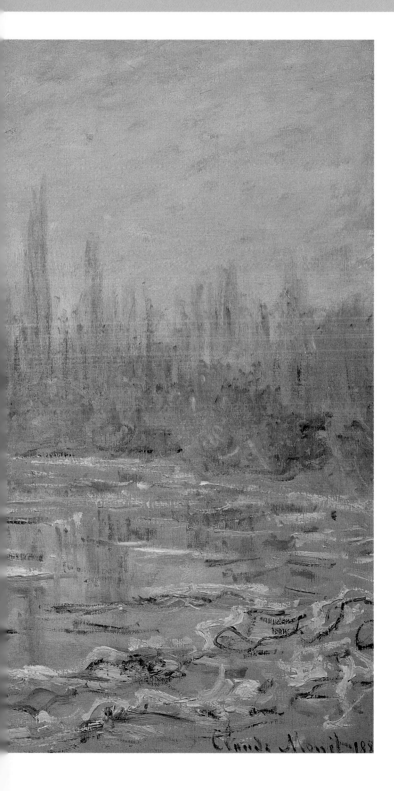

VÉTHEUIL

Ernest Hoschedé had debts of 2 million francs and 152 creditors. His wife Alice was able to recoup some funds and by late summer the entire Hoschedé family had moved with Monet and Camille and their two children to Vétheuil, a small town on the right bank of the Seine, on a raised site dominating a loop of the river. Pooling their resources, all 12 members of both families initially lived in a small house on the Mantes road, but it was very overcrowded and in October they moved to the edge of the town to more spacious accommodation. Monet began to paint again, inspired by the landscape around Vétheuil, but the winter of 1878–9 was a severe one and Camille's health gradually declined. Monet contributed a number of views of Vétheuil to the Fourth Impressionist Exhibition, at 28 avenue de l'Opéra in Paris. He had not wanted to be involved and did not attend, but he desperately needed the money from sales. Caillebotte collected his 29 works and hung them. Renoir and Sisley did not exhibit at all and Degas very much dominated the exhibition with his own work and those of his protégés. Attendance was good – with more than 15,000 people visiting – but the critical reception was disappointingly hostile. That said, Edmond Duranty contributed a positive review to the *Gazette des Beaux-Arts*, singling out Monet for praise.

Throughout 1879 Camille's health continued to worsen and Monet was worried. She suffered an agonizing death on 5 September, probably from cervical cancer, and he mourned her deeply. Despite his infidelity with Alice, he remained deeply attached to Camille, who was just 32. On the day of her death he wrote: 'My poor wife died this morning. . . . I am filled with dismay to find myself alone with my poor children.'

The Thaw on the Seine, near Vétheuil, 1880. *This is one of a number of canvases painted by Monet during the bitter winter of 1879–80 in which he captures the frozen surface of the river breaking into ice floes that are carried downstream by the current.*

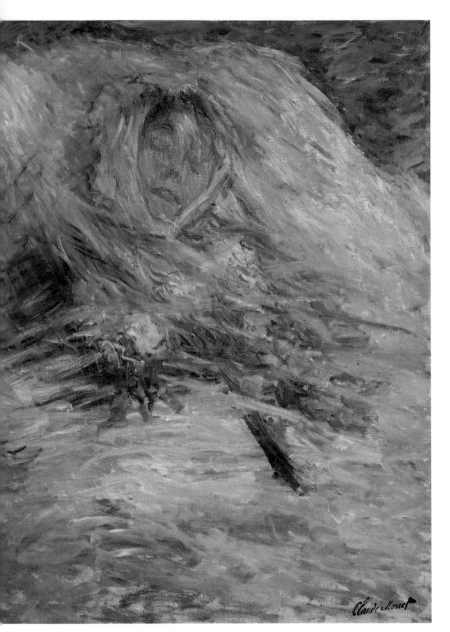

Camille Monet on Her Deathbed, 1879. *In Monet's last painting of Camille in death, she is shown as a ghostly figure, propped up in bed, captured in broad brushstrokes in shades of blue and grey with purple highlights. Her emaciated face reflects her suffering and final peace.*

On 26 September he wrote to his friend Pissarro, 'You, more than anyone, will understand my grief. I am overwhelmed; I have no idea which way to turn, nor how I am going to be able to organize my life with my two children. I am much to be pitied.' He paid tribute to her in a traditional way, painting an extraordinarily moving deathbed scene. He had captured the likeness of Camille on so many occasions and this, his last depiction of her, is poignant and tender. Monet recalled that at her bedside observing her, he became absorbed in 'the coloured gradations which death was imposing on her motionless face'.

The following winter of 1879–80 was harsh and Monet responded with a series of bleak snowscapes that seem to reflect his melancholy, capturing the drudgery of winter in the town itself and the surrounding countryside. The River Seine froze completely, and the spectacular thaw eventually saw massive ice floes on the river, which he captured atmospherically in several compositions. Monet worked at Vétheuil for three years, returning to landscape as his main inspiration and moving away from the scenes of modern life and leisure which had so attracted him in Argenteuil and Paris.

Desperate now for commercial success, Monet reappraised his approach to selling his art. Although still committed to the Impressionist cause, he decided for the first time in 10 years to submit works to the state-sponsored Salon rather than contribute to the Fifth Impressionist Exhibition of 1880. He submitted two large canvases to the Salon, one an experimental view of ice floes on the Seine and the other a more traditional view of Lavacourt on the opposite side of the river. The Jury predictably rejected the ice floes painting and accepted Lavacourt, a more finished composition. Despite being badly hung, it was well received, but it did not sell. Monet also held a one-man show, which opened in June 1880 at the gallery of *La Vie moderne* magazine, organized through Georges Charpentier, a publisher and patron of the Impressionists. Several works were sold, enabling him to pay his debts. Over the summer he painted varied views of Vétheuil, sometimes capturing it from the islands in the River Seine.

THE CONTINUING INSPIRATION OF THE NORMANDY COAST

By September, however, he was visiting his older brother Léon, who had a house near Dieppe, reconnecting with his Normandy roots and finding inspiration once again on that stretch of coastline. A renewed relationship with the dealer Durand-Ruel was also

encouraging – he purchased 15 works from the artist in February 1881, including the ice floes painting rejected by the Salon and two views of the Normandy coast. In March, Monet produced a series of innovative cliff paintings near Fécamp during a month-long stay. Varying his viewpoints and delighting in the massive shapes of the cliffs, he simplified his compositions, often eliminating any figures or shipping, capturing the choppy waves and blue skies in the spring sunlight. The paintings reflected his increasing interest in Japanese prints and the impact of their compositions on his work.

Monet and Alice continued to live together, with their children, moving to Poissy, while her husband Ernest Hoschedé absented himself, attending to his deteriorating financial situation. The landscape around Poissy did not inspire Monet. 'The countryside won't do for me,' he wrote to Durand-Ruel. He also contributed in March 1882 to the Seventh Impressionist Exhibition, sending 35 works to a show of more than 200 paintings. Overall, the reviews were favourable but one critic writing in *Le Soleil* singled out Monet's *Sunset on the Seine at Lavancourt, Winter Effect*, painted at Vétheuil. He said it reminded him of 'a

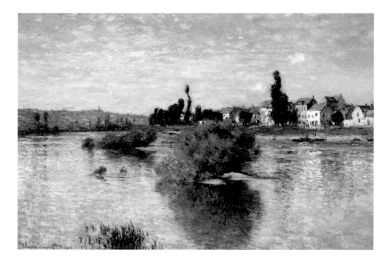

The Seine at Lavacourt, *1880. This was the last painting that Monet submitted to the Salon. It was accepted, but did not attract much attention, except from Émile Zola, who praised it.*

The Road in Vétheuil in Winter, *1879. Monet spent three years in the village of Vétheuil. His portrayal of atmospheric winter scenes may have reflected his own melancholy.*

Cliffs near Fécamp, *1881. Two of Monet's favourite motifs are combined here as he shows the waves crashing into the bottom of the cliff face and the light playing on the stone above that towers over the shingle of the beach.*

The Cliff Walk at Pourville, *1882. The two figures looking out to sea are naturally integrated into the composition and have traditionally been thought to represent Marthe and Blanche, the eldest Hoschedé daughters. This atmospheric work shows the sea now dotted with shipping and 'white horses' on a bright windy day.*

slice of tomato stuck onto the sky, casting a violet light on the water and riverbanks'. Monet had already left for Normandy again, working at Pourville that spring, and once again depicting the dramatic cliffs in works such as *The Cliff Walk at Pourville*.

Monet was captivated by the little fishing village of Pourville, writing to Alice, 'How beautiful the countryside is becoming, and what joy it would be for me to show you all its delightful nooks and crannies!' Alice and the children joined him there that June and it has been suggested that the two figures looking out to sea in *The Cliff Walk at Pourville* are Marthe and Blanche, the eldest Hoschedé daughters. Developing his approach to cliff-top painting, he here inserts the female figures effortlessly into a landscape without disrupting the composition. He stayed on in the area until October that year and was particularly drawn to the isolated mariners' church at Varengeville, nestled at the top of a dramatic cliff, and the Gorge of Les Moutiers, which he painted at different times of day, from early morning to sunset. Sometimes he painted the church atop the vast cliff from the beachside, captured with bold brushstrokes against a bright blue sky, in the morning sunshine, while on other occasions, in contrast, he depicts the sun setting from the opposite vantage point, looking across the gorge with trees in the foreground. In a painting at the Barber Institute of Fine Arts, light from behind the church, silhouetted against a golden sky, dissolves its architectural form in dramatic warm colours and just catches and highlights the foreground foliage as the sun sets.

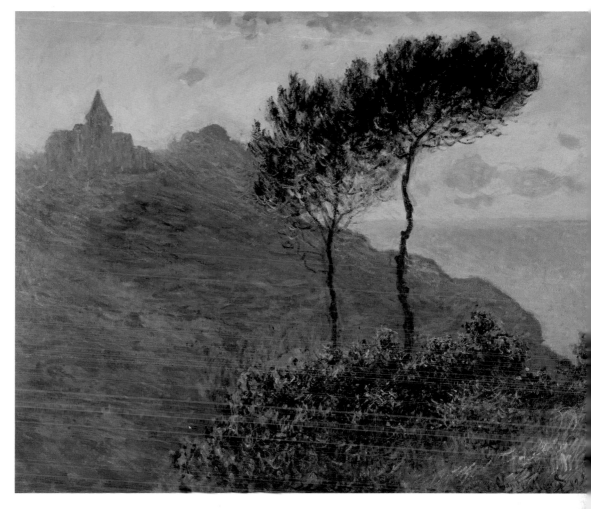

The Church at Varengeville, 1882. One of a series of four paintings of the church, this shows the sun setting to the left of the building. With the light diffusing the boundary between it and the surrounding land, the church takes on an almost mystical appearance.

These expeditions to the Normandy coast for painting excursions continued throughout the 1880s, and some of his most dramatic paintings were produced during this period, as Monet became increasingly interested in the changing impact of weather conditions on motifs. He began to paint several canvases simultaneously, moving from one to the other as the light changed. By this time, he had largely abandoned the Impressionist practice of completing a picture *en plein air*, and was adding the finishing touches back in the studio.

In January 1883, Monet spent three weeks working at Étretat, the fishing village and tourist resort on the Normandy coast where he had painted in the winter of

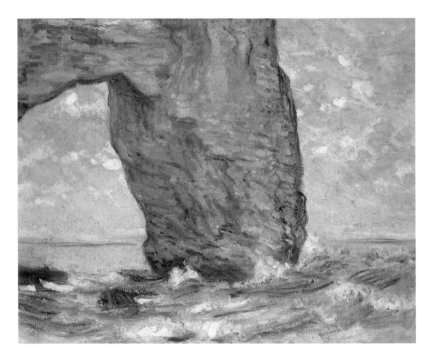

The Manneporte, Seen from Below, *1883. Monet captures the texture of the wet rock, responding to the colour and luminosity of the surrounding sea, framing the natural geological formation dramatically with crashing waves in vigorous brushstrokes at high tide.*

By the River at Vernon, *1883. Bright colours and the clear reflections in the water conjure up a sunny day on the river.*

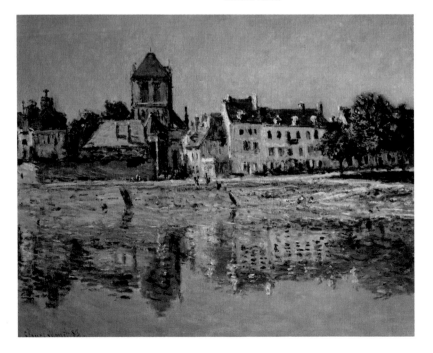

1868–9. It was famous for three impressive natural rock arch formations: the Porte d'Aval, the Porte d'Amont and the Manneporte. Tourist guides at the time drew visitors to view these extraordinary geological features, and Courbet and Boudin had already found inspiration there. Monet was no exception and was captivated too, depicting these rock formations on at least 20 occasions. He set about methodically recording the rocks at differing times of day in ever-changing light, as he began to establish the artistic process that would define his future working.

THE MOVE TO GIVERNY

By the end of February, Monet was back in Paris, for the opening of the second of his one-man shows, which enjoyed good reviews at Durand-Ruel's gallery. Sales were picking up, although money was still an issue and the lease was now up on the Poissy house. Monet decided to make a decisive move with his blended family to a large farmhouse house in Giverny, a typical Norman village on the Seine, near Vernon and 80 kilometres (50 miles) north of Paris, where rents were cheaper. 'I like the countryside around here very much,' he wrote to Durand-Ruel on 15 April. It was the generous dealer who met the costs of his move.

Giverny is now so associated with Monet and his waterlily garden that it is difficult to imagine what it was before he arrived – a quiet secluded village of 280 residents – or what the farmhouse he rented would have been like before the development of the famous gardens. Le Pressoir (the Cider Press) was a large house, which could accommodate Alice and Monet as well as their eight children comfortably. It had pink rendered walls and grey shutters (which Monet quickly painted green), and an old attached barn, which he converted into a painting studio. There were large gardens, including a planted walled garden and an apple orchard. In fact, it was the blossom on the trees that first attracted him to the property. He was 42 years old and this move marked a new beginning.

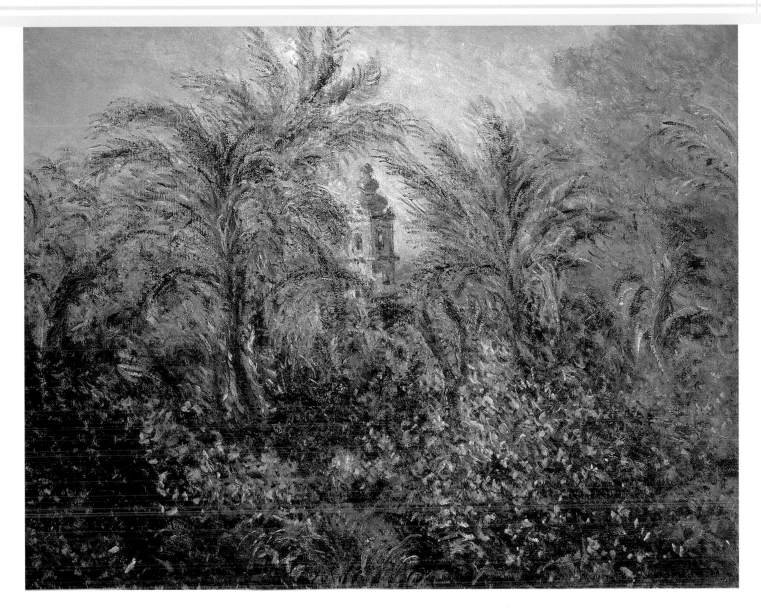

That spring, shortly after they had settled in, Monet received the news that his great friend and inspiration Manet had died. He rushed back to Paris to be a pall-bearer at his funeral – the only Impressionist to have the honour. Later, in 1889, Monet led a fundraising campaign to buy Manet's famous *Olympia* from his widow and donate it to the Louvre as a fitting memorial to his mentor. Immediately after the funeral, Monet found solace for his loss in his new garden, planting vegetables and soon deciding to remove the fruit trees gradually and the box trees, creating instead a flower garden that he could paint, and later recording scenes of blissful family life in the garden – 'I dug, planted, weeded myself; in the evenings the children watered.'

Monet's painting initially got off to a slow start due to rainy weather, and his first paintings were of the river and church at Vernon rather than his garden, which after initial planting needed to mature. Visitors gradually became an important part of Monet's life at Giverny and among the first was Gustave Caillebotte, who also shared his enthusiasm for gardening and came specially to consider Monet's longer-term plans for the garden. By the end of the year Monet was taken up by a new and somewhat different commission from Durand-Ruel, to create more than 30 panels depicting flowers and fruit. These were not completed until 1885.

Garden in Bordighera, Impression of Morning, 1884. Monet visited the Italian estate of Bordighera with Renoir in 1883. In this painting, Renoir's influence is apparent in the use of light brushstrokes to portray a place Monet described as an 'earthly paradise'.

BELLE-ÎLE

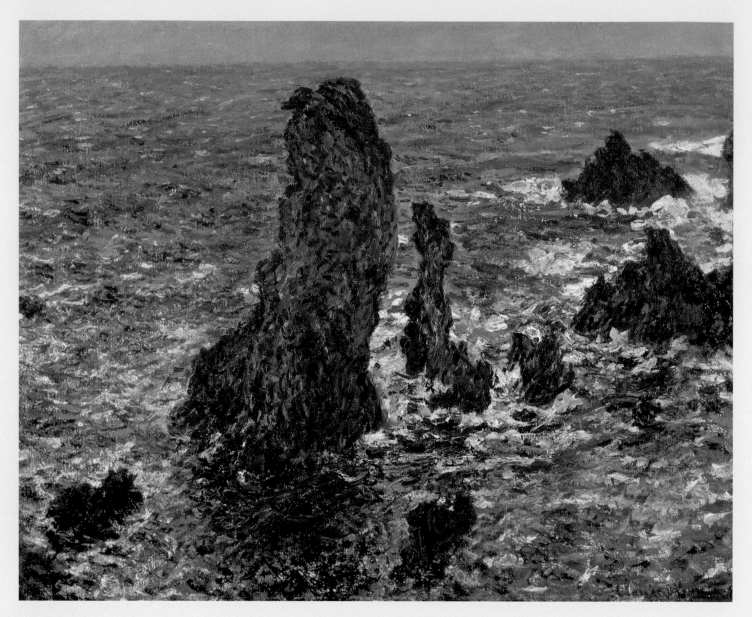

The Rocks at
Belle-Île, 1886.
*The Breton coastal
terrain was difficult
to traverse and
filled with obstacles
which Monet had
to overcome to find
the subjects for his
paintings.*

In the autumn of 1886, Monet found inspiration on Brittany's Belle-Île in the Gulf of Morbihan. Establishing himself in Kervilahouen, a small village to the west of the island on the Atlantic side, he produced some 39 works. He wrote to his old friend and patron Caillebotte, 'I am in a wonderfully wild region, with terrifying rocks and a sea of unbelievable colours; I am truly thrilled, even though it is difficult, because I had got used to painting the Channel, and I knew how to go about it, but the Atlantic Ocean is quite different.' Initially the wild, inaccessible landscape and the constantly changing weather were challenges, but eventually he found suitable positions to set up his easel along the majestic rugged coastline, enabling him to paint in the open air and capture the ever-changing light. 'The sea is completely beautiful', he wrote to Alice in September,

The Rocks at Belle-Île, the Wild Coast, 1886. *Little space is allocated to the sky in this image, in the tradition of Japanese prints, while intense colours emphasize the dramatic violence of the Atlantic Ocean.*

One painting in the series Monet would later exchange with Rodin for his work *Young Mother in the Grotto*, when they worked on an exhibition together. His collection of art was expanding and his circle of friends and supporters was broadening. Such networking would help him enhance his reputation and the success of his sales. In November 1886, he met the novelist Octave Mirbeau, who already supported his work in the press. Towards the end of November, Monet headed back home to Giverny. He worked to complete his Belle-Île paintings in his studio, and in 1887 he returned to depicting figures out of doors. Reflecting idyllic family life at Giverny, he captured his step-daughters Blanche and Suzanne reading, painting, enjoying time on the river in a series of dazzling, dreamy works, which contrast with the often dramatic and bleak Belle-Île canvases.

'and as for the rocks they are a tangle of extraordinary coves, spikes and needles.'

The works often reflect the influence of the Japanese artist Hokusai on his compositions, with low horizon lines. Monet had begun collecting Japanese prints, especially the work of Utamaro, Hokusai and Hiroshige, and it is interesting to note that those artists often made multiple views of the same motif. On Belle-Île, he gradually started to explore the ideas that would inspire his series paintings in the 1890s, carefully observing the sheer cliffs and stunning rock shapes, at different times of day as the light changed them.

It was here that he met the art critic for *La Justice* newspaper, Gustave Geffroy, who became a close friend and valuable supporter of his work. Geffroy later recalled, 'Monet worked in the wind and rain. His easel was anchored down with cords and stones.'

In the Woods at Giverny: Blanche Hoschedé at Her Easel with Suzanne Hoschedé Reading, 1887. *An accomplished painter, Blanche learned her craft from Monet.*

Tulip Fields in Holland, *1886. The Dutch landscape impressed Monet enough during his 10-day visit in 1886 that he decided to paint the bulb-fields around the Rijnsburg windmill with their sea of colours.*

EXCURSIONS

Although Monet found great peace at Giverny and the gardens became a major project, he initially required stimulus elsewhere and regularly made excursions to find new themes. In the autumn he visited Rouen and then, in late December, he went with his old friend Renoir to the Mediterranean, visiting Paul Cézanne at L'Estaque, near Marseille. They travelled on to the Ligurian Riviera in Italy, which so impressed Monet that he returned alone to Bordighera, staying until April to capture the bright colours of the Mediterranean, views of the palm trees and villas, the lush gardens and the glistening blue sea. He also painted Menton and Cap Martin, just over the border in France. The artist was incredibly productive in the Mediterranean scenery, painting more than 50 vibrant canvases. Some, such as *Garden in Bordighera, Impression of Morning*, show the influence of Renoir's landscapes and have feathery light brushstrokes.

During the summer of 1885 Monet returned to the Normandy coast, painting once more at Étretat. The spring of 1886 saw him travel to Holland, at the invitation of a French diplomat in The Hague, Baron de Constant de Rebecque. Although Monet had been to Holland before, he had never tried to capture the fields of vibrantly flowering tulips interspersed with windmills. He spent about a month in The Hague in fine weather, travelling through Rijnsburg, which he painted, and Sassenheim. He produced five paintings, which he brought back to finish in the Giverny studio. Two of his Dutch paintings were shown at the Fifth International Exhibition of Paintings and Sculptures at the Georges Petit Gallery and from this period Monet, who had been concerned about Durand-Ruel's financial problems caused by the crash of the Union General Bank, dealt with both dealers to try to ensure his sales were buoyant.

It was in April 1887 that Monet first sold a work to Theo van Gogh, manager of the Galerie Boussod, Valadon & Cie on Boulevard Montmartre, Paris. The following year, after Monet had enjoyed a prolific painting campaign in Antibes, creating a series of 30 freely executed works in luminous colours, the gallery purchased 10 of them. Monet was now effectively working with three Parisian dealers and increasingly broadening his patronage base. His clever manipulation of dealers helped to secure his long-term financial success. Initially, however, Monet did not see the potential for the American market, which Durand-Ruel was encouraging him to pursue. He had written to the dealer in early 1886, 'I would like to share your hopes for America,' but explained, 'I would prefer above all to have my paintings known and sold here.' Durand-Ruel organized the first exhibition of Impressionist work in America in April 1886, displaying 40 Monets. The exhibition attracted comment and attention, though not all the reviews were favourable. On returning to Paris, Durand-Ruel explained in a letter to the artist Fantin-Latour, 'I had a lot of success with paintings

The Petite Creuse River, 1889. *During the spring of 1889, Monet painted many scenes of the River Creuse. These were presented at a joint exhibition with the sculptor Auguste Rodin at the Galerie Georges Petit in Paris later in the year.*

that took 20 years to be appreciated in Paris. I sold Monets, Renoirs and many others.' He was encouraged enough to open a gallery in New York in 1887. The American market was to be key to his success, as well as Monet's. Meanwhile, in 1888, rival dealers Boussod, Valadon & Cie also set up a New York Gallery selling works by Monet.

At the end of the 1880s, Monet visited the valley of the River Creuse in France's Massif Central region for another painting expedition. Once again, he produced a group of pictures in which he explored the changing effects of light and weather conditions on the same view at different times of day. The paintings, some 20 in all, demonstrated his vibrant use of colours – deep purples, red and blues. He struggled with the subject, the ever-changing river which some days flowed much faster than others, and the weather. Monet now actually uses the word 'series' in a letter to Alice of April 1889: 'With this awful gloomy weather . . . I am

terrified when I look at my paintings, they are so dark. Moreover, some of them even lack sky. It's going to be a lugubrious series.' Groups of pictures which he produced there, from nearly identical locations, come very close to being described as a deliberate series of works. Monet had been refining this approach to painting throughout the decade and now the scene was set to create the series pictures for which he is so well known today. On his return from the Valley of the Creuse, his immediate focus was an exhibition he was organizing with art dealer Georges Petit, which would show his work and that of Rodin together for the first time. The exhibition opened in July 1889 and ran until September, with 145 of Monet's works covering his whole career, including the recent Creuse paintings and, interestingly, one of the first paintings he produced of a grainstack. He was now establishing his interest in the serial motif, which he would continue for the remainder of his career.

CHAPTER 5
The Series Paintings

Monet's attachment to Giverny was growing and in December 1890 he purchased the farmhouse he had been renting, confirming that this was now his and the family's permanent residence. Following his relentless painting expeditions during the 1880s, he concentrated in the 1890s on series paintings, finding subjects in Giverny or nearby. Sixteen years after the First Impressionist Exhibition, Monet had now developed his own interpretation of Impressionism, his series paintings emphasizing repetition: pictures were painted from similar vantage points and clearly related to each other. He intended these to create an impact when they were displayed together. Visitors and critics alike would be able to understand the relationship of one work to the other. Though begun *en plein air*, the paintings were completed in his studio, as had been his process for some time. The most famous of these series paintings was probably the first, which he began in 1890.

THE GRAINSTACKS SERIES

In the 1880s, Monet occasionally captured haystacks in his landscapes of recently scythed fields around Giverny. However, his earliest depictions of grainstacks – which are large stacks of corn, rather than hay – first appear after the 1888 harvest at Giverny. The titles of the paintings have popularly been mistranslated into English as 'haystacks', but they were in fact stored

Opposite: Haystack at Giverny, *1886. A precursor to Monet's grainstack paintings (which have been widely mistermed haystacks), this features a genuine haystack in the foreground.*

Right: Haystacks: Autumn, *Jean-François Millet, 1874. This was one of a series of four paintings portraying the seasons, commissioned in 1868 by the manufacturer Frédéric Hartmann.*

sheaves of grain (wheat, although some could have been oats and barley) and look very different to the haystacks Monet did paint (see page 61).

The tradition in that area of Normandy was that these grainstacks were conical in shape, built on freshly mown fields by the farm workers. They were substantial structures 4.5–6 metres (15–20 feet) high and they protected the grain against both the elements and rodent infestations. For Monet, they gradually became the focus of his first recognized series paintings. Other artists had observed haystacks in their work previously, such as Jean-François Millet whose *Haystacks: Autumn* (1874) was part of a series depicting the four seasons commissioned by the industrialist Frédéric Hartmann. They also appear in the background to his *The Gleaners* (1857). Such

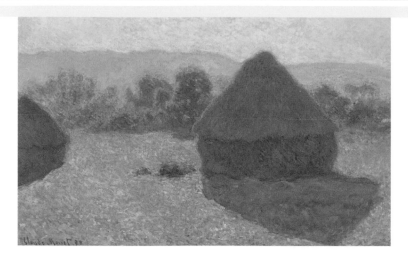

Haystacks, midday, *1890. The different effects of the light on the grainstacks fascinated Monet. In this painting it was their distinctive shadows that provided the focus of the piece.*

Stacks of Wheat, End of Summer, *1890. These grainstacks could be found just outside Monet's farmhouse in Giverny, making it easy for him to track them through the seasons.*

reflections of rural life in France indicate the productivity of the farmland. Monet placed his grainstacks centre stage, with no farmworkers or sheep for distraction, and focused on them as the main subject matter in his compositions, capturing the nuances of light and shade at different times of day and during changing seasons. Close by the

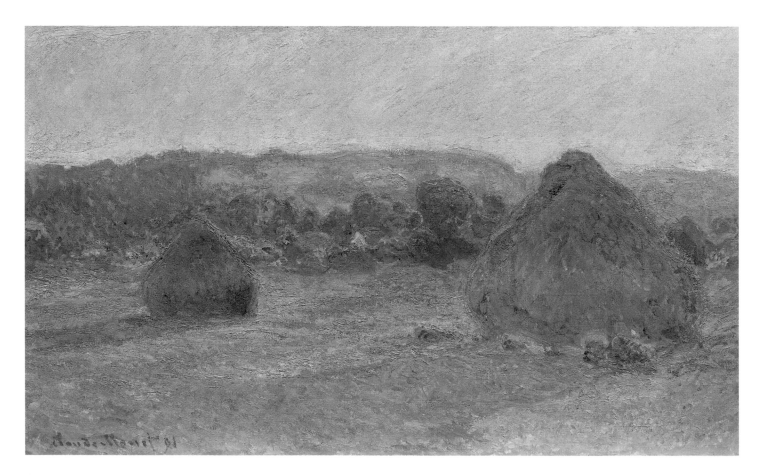

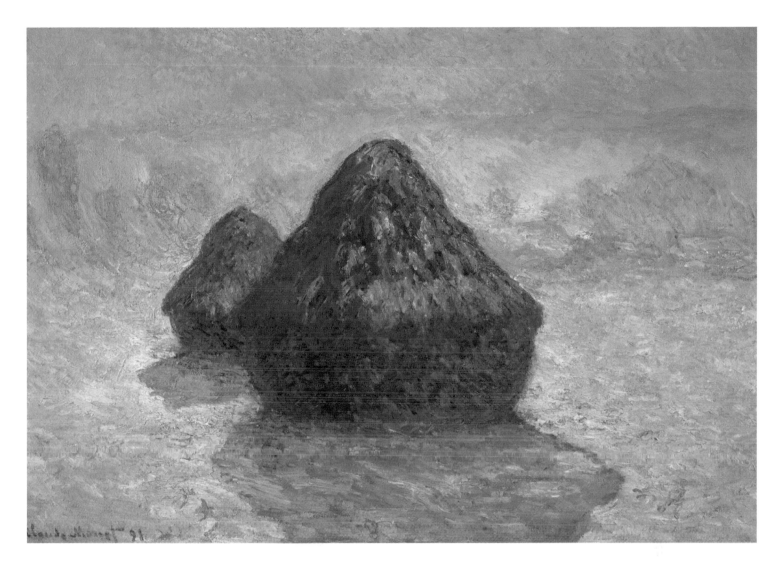

farmhouse at Giverny was a parcel of land used for grainstacks, belonging to his neighbour Monsieur Quéruel, who had one of the largest farms in the area. Thus the grainstacks were literally on his doorstep and very accessible. He is said to have persuaded the farmer to leave them that year for as long as possible so that he could observe them through to the spring of 1891.

For many years, Monet's artistic process involved repeating related motifs, observing them at different times of day. Gradually, he began painting canvases simultaneously to capture the changing effects of light and atmosphere throughout the day, switching canvases as the light and weather conditions changed, taking them all with him to paint *en plein air*. He continued the process over a period of months, from the late summer through to the following spring, chronicling the effects of the weather. The first series of *Grainstacks* is generally considered to comprise 25 canvases, begun in late summer 1890 (see opposite) and continued through the following spring of 1891 (see page 64, bottom). During this period, he clarified his working practice. Sometimes he focused on one grainstack, sometimes on two, depicting the different lengths of shadow cast by the sun at various times of day. Initially, he focused on two grainstacks (see opposite and above), which are recorded in the summer sunshine, then gradually he recorded the winter frosts and fogs through a series of images reflecting the impact of snow or mist (see above and page 64, top). When he was focusing on just one individual stack, it

Haystacks: Snow Effect, 1891. *The muted winter light and coating of snow create an eerie effect where the shadows take centre stage.*

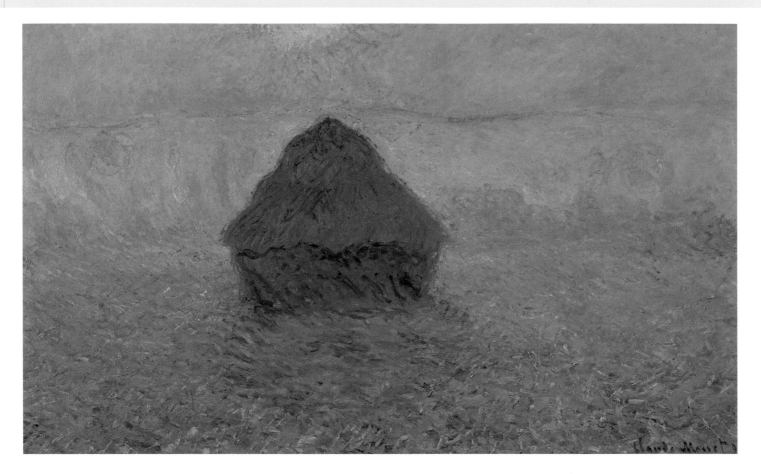

Grainstack, Sun in the Mist, *1891. To capture the glow of a misty sunset, Monet used short brushstrokes, creating a fire-like halo effect around the grainstack.*

Haystacks in the Sun, Morning Effect, *1891. The bright morning light produces a vivid and colourful landscape of meadows after harvest.*

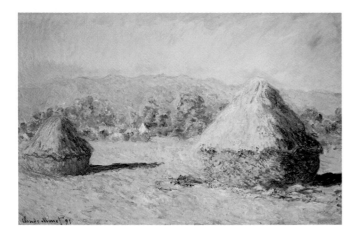

sometimes appeared to have a halo of light around it, highlighting it against a brighter sunset (see above). The brushwork is often broken and flickering, the colour intense, brilliant and luminous. The resulting paintings of the stacks have a particular lyrical feel to them and have been described as abstract, having a major impact when they were exhibited and influencing many later artists.

In early 1891 the Boussod, Valadon gallery purchased three *Grainstacks*, paying 3,000 francs each. In May of that year, 15 were exhibited at Durand-Ruel's gallery in an exhibition that had a catalogue with a preface by Gustave Geffroy. Monet's fellow Impressionist Pissarro reflected on the popularity of his work at this time: 'People want only Monets, it seems he can't paint enough to go round. The most amazing thing is they all want *Grainstacks: Evening Effect*.' A few weeks later, after the exhibition at Durand-Ruel's gallery opened, Pissarro made his own assessment of the series: 'These paintings seem to me very luminous, undoubtedly the work of a master; the colours are pretty rather than strong, the draughtsmanship fine but drifting, particularly in the backgrounds. Nevertheless, he's a very great artist!' Monet had indeed found a formula for his painting that was intellectually and artistically challenging but also in great demand with the art-buying public. The first showing of his *Grainstacks* series was his most successful exhibition thus far financially and also met with considerable acclaim.

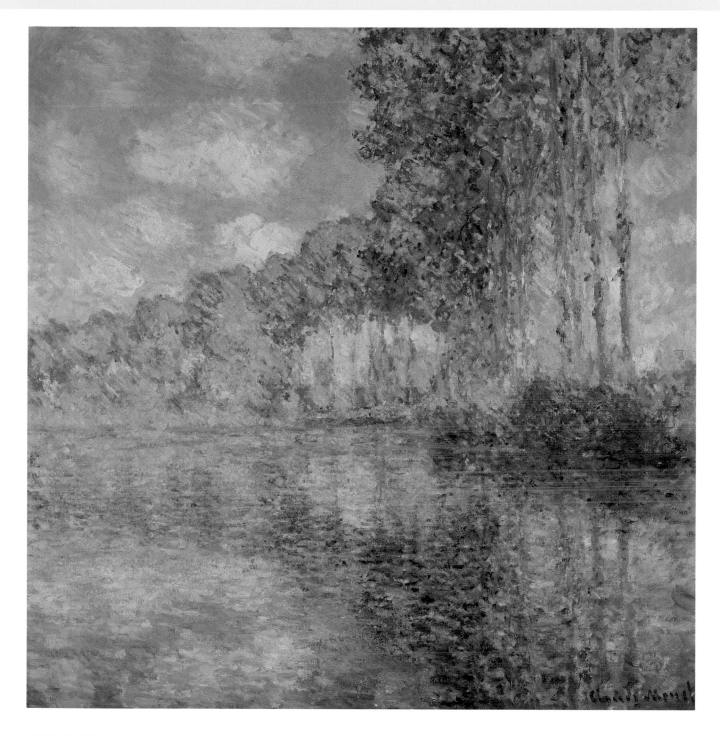

THE POPLAR SERIES

Enthused by the success of his *Grainstacks* series, Monet began, probably in the late spring of 1891, a second series concentrating on a single motif: poplar trees, which had regularly appeared in landscapes he had painted previously. Now one particular line of poplars attracted him. These ran along the bank of the River Epte, about two kilometres (one mile) upstream from the farmhouse, and were reached by rowing boat at the point where the Limetz forks away at the edge of marshland. He often reflects the S-shaped bend in the river in his canvases. Initially painting on his floating studio, especially fitted with grooves to hold his multiple canvases, Monet captured these tall, elegant poplar

Poplars on the Epte, 1891. On the River Epte, near Monet's home in Giverny, stood a row of poplar trees. In total, he made 23 paintings from this scene.

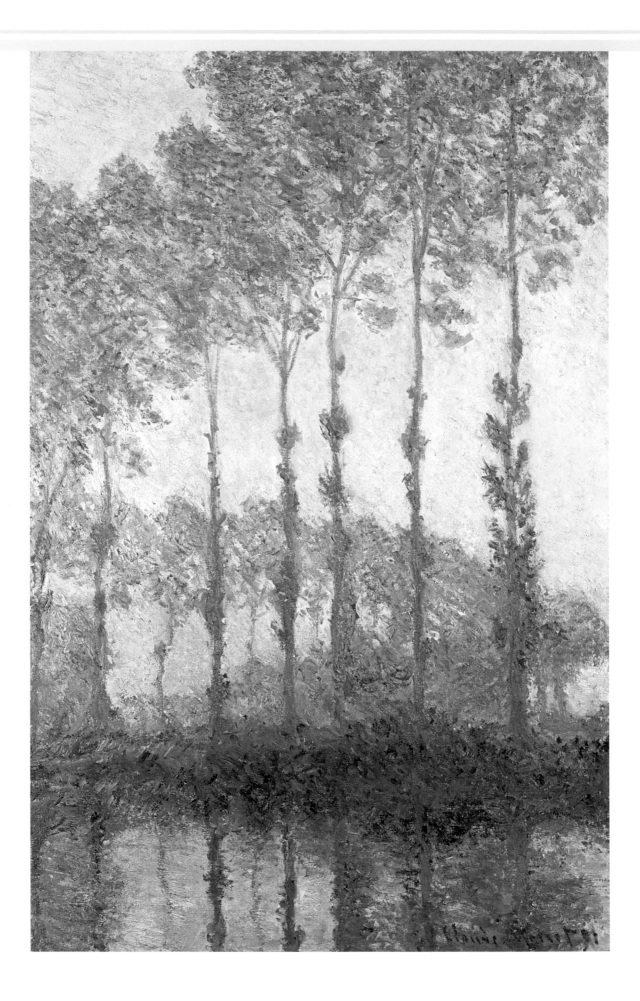

trees against blue summer skies, recording their reflected images in the sunlit river below with swift brushstrokes. Sometimes, he also painted from the riverbank. In all, he produced 24 pictures of poplars on somewhat unusual canvases which are square in shape.

Undoubtedly the logistics of painting the trees was more complex than a field with grainstacks close to his farmhouse studio, and inevitably Monet complained about the process, particularly about the weather, in a series of letters. 'I have had nothing but disappointments with my poor trees, and I am not at all satisfied with them,' he wrote early on in the summer, and later commented that the bad weather 'reduces me to despair about my trees'. He was even said to have become so frustrated on one occasion that he threw all his painting materials into the river. But the final straw came when the trees he was painting were put up for auction for timber by the local village in August 1891. Monet was forced to pay a timber merchant who bought the trees, to prevent them being felled immediately, so that he could continue painting them until the spring of 1892. An autumn view of the trees reflects the changing colours that the seasons bring and Monet's success in preventing the trees from being chopped down. In each work, the rhythm of the trees and the seasons is captured in changing light, the canopy of leaves and the different colours reflected in the river. Sometimes it is the bare trunk of the tree that is the focus, on other occasions the extensive canopy of foliage above, and he contrasts the straight trees with the curving course of the river itself. He accentuates the soaring lines and elegant shapes of the poplars – a stark contrast to the dumpy grainstacks that obsessed him

throughout the previous winter and spring.

Monet's depictions of the poplars gradually become more abstract and decorative in examples such as *The Four Trees*. This is a powerful composition in which he highlights four tree trunks in the foreground in shadow, cutting off their canopy of leaves and depicting the continuing line of trees highlighted by the sunlight, which recedes into the distance, hugging the banks of the river as it bends back on itself. Monet creates a vibrant surface effect with light dabs of pigment, building his forms with pure colour. His mastery of technique means that today the work has survived in excellent condition and remains as luminous today as when it was painted.

As with the *Grainstacks*, this series of intensely observed poplars was a success. Fifteen of the works were exhibited together in Paris between 29 February and 10 March 1892 in a one-man show organized by Durand-Ruel, which confirmed Monet's reputation as among the most innovative painters of the time. His friend Geffroy noted of the integrated display, 'This changing and harmonious poem develops with nuances so closely bound together as to create the feeling of a single work of inseparable parts.' The paintings took on 'their true

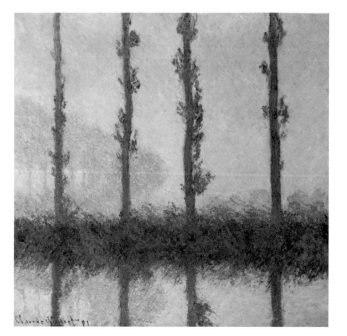

The Four Trees, *1891. In a more abstract approach, Monet here cuts off the tops of the trees and uses the reflections in the river foreground to highlight the strong motifs of the trunks.*

Poplars on the Banks of the Epte, *1891. The subject of tall, thin poplars was a distinct contrast to* Grainstacks, *but here too, light and the time of day shaped Monet's work.*

value only through the comparison and succession of the series'. The critics recognized the decorative as well as the poetic impact of these powerful studies of trees and the recording of the changing seasons, rhythm, colour and light. Even before the exhibition opened, Monet had sold 12 of the *Poplars* canvases. Durand-Ruel purchased seven of them himself, paying 4,000 francs each, but Monet was increasingly astute and would not agree to selling solely to one dealer. He had exhibited some *Poplars* with Boussod, Valadon in January before Durand-Ruel's high-profile exhibition opened in February. On 22 March, he wrote to say how pleased he was with the success of the exhibition: 'I have it from several authorities that the effect has been considerable,' but in the same letter he firmly explained that he could not have an exclusive relationship: 'I think it absolutely damaging and bad for an artist to sell to one dealer only.' He elaborated clearly his new approach: 'From now on, I no longer wish to sell my paintings in advance; I want to finish them first without hurrying and I want to wait a while before deciding which ones I will sell.' This reflects Monet's improved financial position and his desire to take more control of his future. Through the good offices of Durand-Ruel, Monet had started to be popular with American collectors. 'We have plenty of visitors each day' to the exhibition, Durand-Ruel told him. 'You see I was not wrong to carry out my campaign in America.' A selection from the *Poplars* series was shown in New York in June 1892. Two works from this passed into the collection of Potter and Bertha Palmer, and were eventually left by Bertha to the Art Institute of Chicago in 1922, along with many other key works by Monet.

The subjects of Monet's first two series paintings may seem random but in fact they reflected the prosperity of the French countryside, and in selecting poplar trees he chose a well-known symbol of *La France*, rich in historical references that would not have been missed by French audiences. For his next series he selected one of the oldest Norman structures in France, Rouen Cathedral, whose construction began in the twelfth century and was completed 400 years later. It was a choice that chimed with a general revival of interest in Catholicism in France in the 1890s, although Monet himself was a non-believer.

COLOURFUL CATHEDRALS

Encouraged by the success of his *Poplars* series, Monet now sought to concentrate on one single architectural motif for the first time: the massive and impressive façade of nearby Rouen Cathedral. He went to stay with his brother Léon in February 1892, later moving on to the Hotel de l'Angleterre. He initially set up in an empty apartment opposite the cathedral but then had to break and return to Giverny

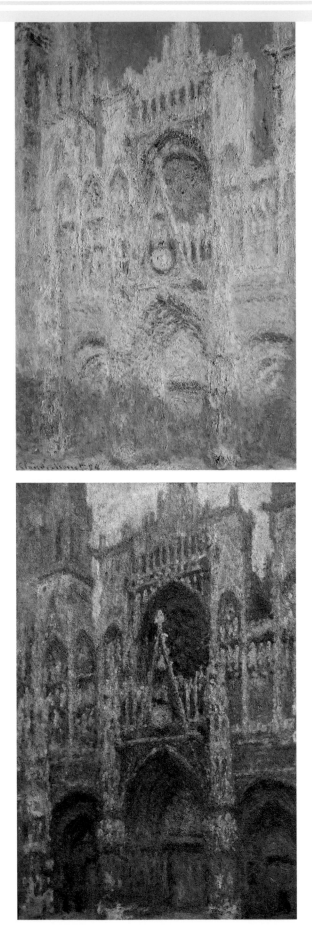

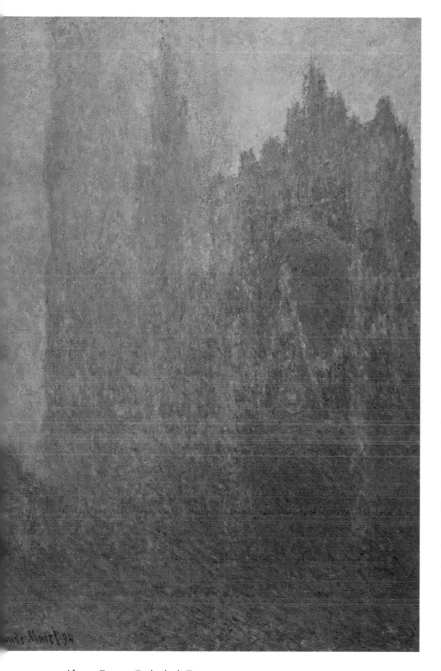

Above: Rouen Cathedral, Foggy Weather, *1894. Fog blurs and obscures the harder outlines of the cathedral's Gothic architecture.*

Opposite, above: Rouen Cathedral at Sunset, *1894. The distinctive light of the setting sun creates a soft, warm view of the cathedral.*

Opposite, below: Rouen Cathedral, the portal; grey weather, *1892. In the light of a cloudy day, browns and greys dominate the façade.*

because he was unwell. On returning two weeks later, the apartment was no longer available, so he had to move to an empty draper's shop, and from this viewpoint he observed the famous west façade at a slight angle, which is how it appears in the majority of this series. (Only two works have a direct view of the cathedral.) The location enabled him to observe the sun in the early morning rising up behind the edifice, creating an image of the façade in bold silhouette. Then the sunlight gradually cascaded over the building in the early afternoon, glistening on the stonework. As the afternoon progressed, so shadows emerged from the square, with just the highest points of the cathedral reflecting light at the end of the afternoon. Working simultaneously on several canvases, he captured the changing nuances of the appearance of the cathedral. He carefully tracked the shifting light across the stones of the medieval structure, from the bright morning light to the vibrant colours created by the setting sun on different days, as can be seen by comparing the results.

Monet worked for almost three months steadily on the project, from February to April, struggling to capture the complexity of the ancient façade, in different weather conditions, from sunny conditions to grey days and fog. In one of his letters to Alice, he confessed, 'I am worn out, I give up, and what's more, something that never happens to me, I couldn't sleep for nightmares: the cathedral collapsing on me, it seemed to be blue or pink or yellow.' And by mid-April he was back at Giverny, 'absolutely discouraged and unhappy'. However, he returned with renewed vigour, from February to April 1893, to continue the series and capture the façade at the exact same time of year as before. This time he had a space over the draper's shop, and the artist's view of the cathedral once again was just slightly altered. From here, he painted a further 17 canvases. In each of his paintings, the looming west façade, with its central rose window, fills the whole of the canvas, viewed close-up and cropped to the sides. The façade is renowned for the beautiful Gothic religious sculptures adorning it, but Monet dissolves these details in the atmosphere that envelopes the building. 'To me the motif itself is an insignificant factor,' he wrote, continuing, 'what I want to reproduce is what exists between the motif and me.' Capturing the fluctuating atmosphere became an obsession: 'Everything changes, even stone.' He did not complete all the cathedral paintings in Rouen but continued to work in his studio at Giverny after he had left Rouen, and into 1894. The paint surfaces of each work are dry and thickly layered with an encrusted appearance reminiscent of

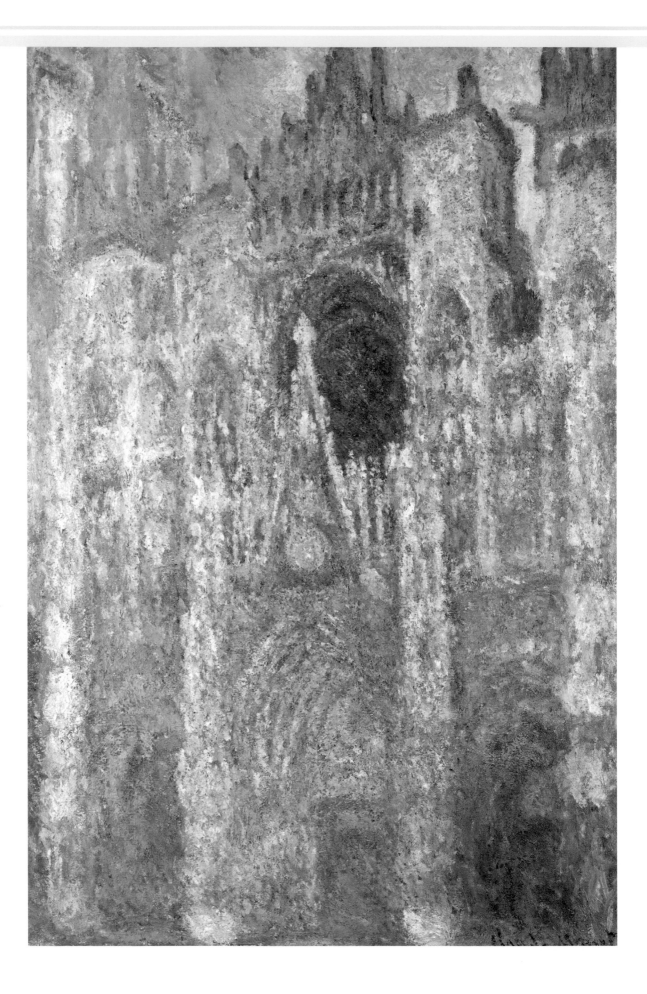

Rouen Cathedral, Blue Harmony, Morning Sunlight, *1894. The* Cathedral *series consisted altogether of 31 paintings, portraying the building in many different lighting conditions and atmospheres.*

The Thames at Charing Cross Bridge, *1899. The railway bridge leads across the shimmering river into Charing Cross station. Smoke billows from trains, while the Houses of Parliament rise up in the distance.*

the rough texture of the weathered stone of the façade itself. It was at this point, when harmonizing the series for display, that he signed and dated 20 of the pictures '1894', even though he had worked on them in 1892 or 1893. These were the works he selected for an exhibition in Durand-Ruel's Gallery in May 1895, three years after beginning the series. He chose only works he thought were 'complete' and 'perfect'. Durand-Ruel was concerned that Monet's price of 15,000 francs was too high and eventually the figure agreed was 12,000 francs. By the end of the exhibition, eight of the 20 Cathedral canvases had been sold.

Durand-Ruel's exhibition of 40 works by Monet also included views of Vernon, one *Grainstack*, one *Poplar* painting, two of ice floes and several Dutch tulip-field paintings. The exhibition was another success critically, the critic Camille Mauclair stating, 'Monet is the most prodigious virtuoso that France has seen since Manet.' Most significantly, the radical politician and journalist Georges Clemenceau, already a great supporter of Impressionism and friend of Monet, published a long article in *La Justice* on 20 May 1895 under the title 'Révolution de Cathédrales'. In it he wrote: 'Rouen cathedral is an unchanging and unchangeable object, yet it is one which provokes a constant movement of light in the most complex way. At every moment of every day the changing light

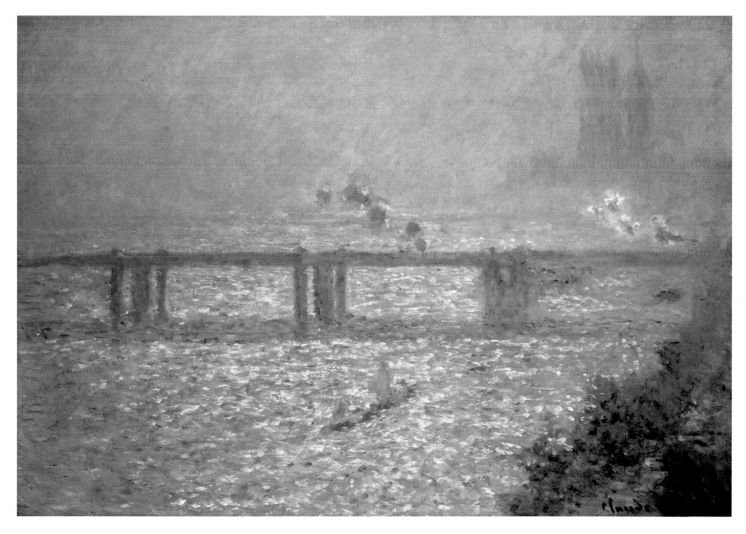

creates a new view of the cathedral which seems as though it were constantly altering . . . stone itself becomes an organic substance, and one can feel it being transformed as one moment in its life succeeds another.' Clemenceau called upon the newly elected President of France, Félix Faure, to purchase the whole Rouen Cathedral series for the nation: 'remembering that you represent France, perhaps you will consider endowing France with those twenty paintings, that together, represent a moment for art.' Contemporary artists also recognized the significance of what Monet had achieved. Pissarro wrote to his son in June of his excitement on seeing the series: 'I find in it that superb unity which I myself have sought for so long,' and Cézanne felt that they were 'the work of a determined man, carefully thought out, trying for the most subtle and elusive effects'. The young Paul Signac admired them too, but not everyone was impressed. Monet's old teacher Boudin recommended the exhibition to friends but

The Houses of Parliament, Sunset, 1903. These buildings inspired Monet during his visits to the city around the turn of the twentieth century.

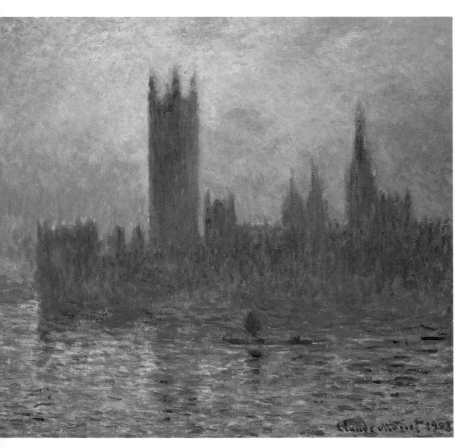

cautioned that the *Cathedrals* were 'very strange'. Needless to say, the works were not acquired for the French nation and are now scattered in private and public collections across the world, groups of them sometimes coming together for exhibitions. The French state did purchase one work, *Rouen Cathedral, the portal, harmony in brown*, for the Musée de Luxembourg (the collection of modern art in Paris), which was supported by Monet's friend Clemenceau, who by then had himself become Prime Minister.

The impact on artists internationally of this particular series has been significant, from Mondrian and Picasso to Kasimir Malevich, the Russian artist who founded the Suprematist movement, and the pop artist Roy Lichtenstein. Malevich wrote, 'Monet's cathedral has a capital importance for the history of art and forces entire generations to change their conceptions.' Lichtenstein is famous for his 1960s Pop paintings, but in 1969 his appropriation (or what he often called 'vulgarization') of other artists' work continued with his two print series inspired by Monet's *Cathedrals* and *Grainstacks*.

LONDON AND THE THAMES

Monet continued to paint series pictures inspired by architecture, venturing further from Giverny to record his Thames series from 1899 to 1902, and in 1908–9 he went to Venice. He knew London from his exile during the Franco-Prussian War and had made a reconnaissance trip in late 1898, visiting his younger son, who was ill. In London, he applied his series technique to a number of metropolitan subjects, capturing mostly modern buildings or bridges built in his lifetime. By 1899, aged 59, he was an established, successful artist who could afford to stay at the Savoy Hotel, taking a suite on the fifth floor. From there, Monet observed Charing Cross Bridge and Waterloo Bridge, often in foggy atmospheric conditions. He famously admired these fogs: 'I so love London! But I love it only in winter. It's nice in summer with its parks, but nothing like

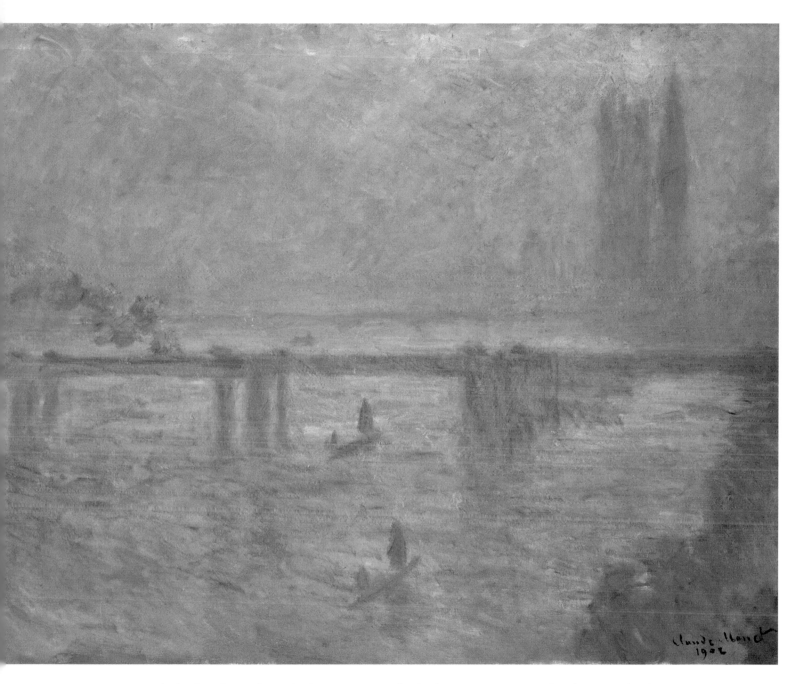

it is in winter with the fog, for without the fog London wouldn't be a beautiful city. It's the fog that gives it its magnificent breadth.'

He began with the bridges. Eventually there would be 35 paintings of Charing Cross Bridge (page 71 shows an early example). This was a railway bridge into Charing Cross station and the billowing smoke from trains can be seen as they move across it. Monet returned to France with unfinished canvases in November, but went back to London in February 1900, finding inspiration from the Houses of Parliament (or Palace of Westminster) as well, a building that had just been completed when he was first in the city. It appears in the distance of many of the Charing Cross bridge scenes (see above and page 71) but now he focused on it completely. To position himself to paint the Palace of Westminster, he had to move to rooms

Charing Cross Bridge, 1902. *Monet painted 35 scenes of Charing Cross Bridge from his room at the Savoy Hotel.*

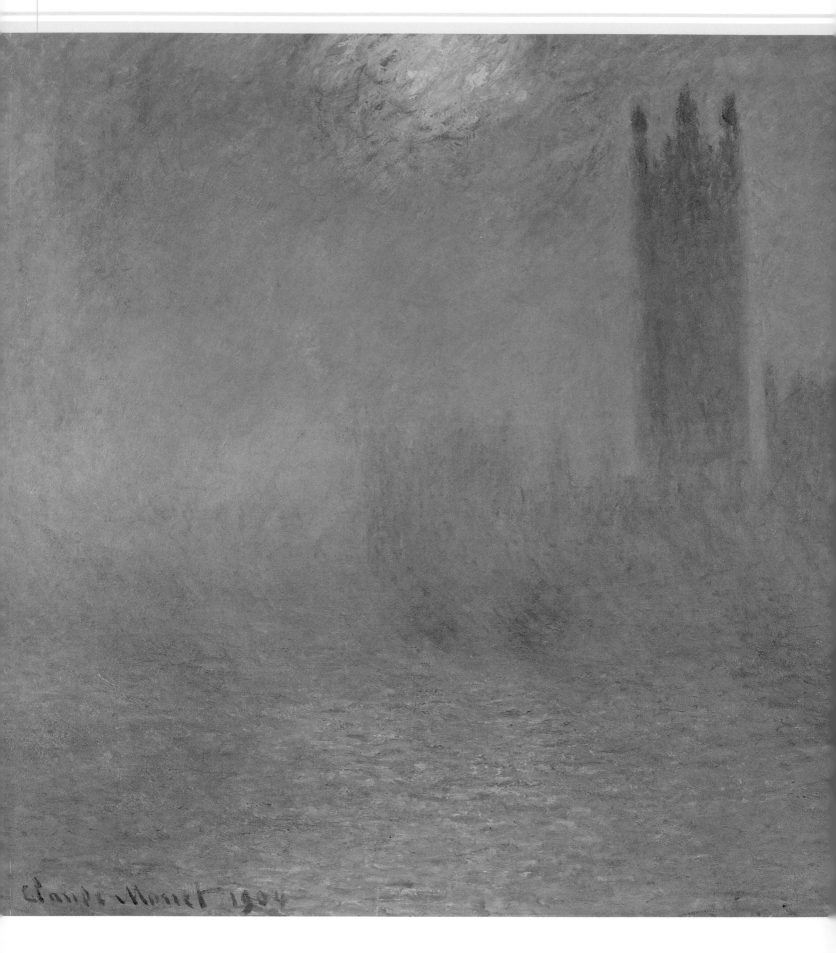

Claude Monet 1904

in St Thomas's Hospital for the best view. He produced 21 canvases of the palace.

A pattern of work evolved which consisted of working in the mornings at the Savoy and moving from the hotel to the hospital every day in the late afternoon, when the sun was low in the sky. He often depicts the palace late in the day. The setting sun is seen behind the building and also reflected in the dappled river, while the building is silhouetted by the light and has a smokey, purplish tinge. The Thames was a busy waterway, too, and Monet depicts boats on the river in many of these scenes. One year later, in another work in the series devoted to the Palace of Westminster, the colours are intense and he represents the vibrant sun breaking through the fog, dissolving the architecture in bright, luminous light. Freer brushstrokes create a harmonious whole with no foreground distractions (see opposite). In March 1900, Monet wrote that he wanted this series to be 'a series as interesting as the Rouen Cathedral' and later in 1920 described his working method in London: 'At the Savoy Hotel or St Thomas's Hospital from which I took my viewpoints, I had up to a hundred canvases on the go – for a single subject. By feverishly searching among my sketches, I would choose one that did not differ too much from what I saw before me – but would then often modify it completely.'

By 18 May, he felt that 65 works were now nearing completion. He returned once more to France over the summer of 1900, working on the canvases back in his new studio, and was in London a further time in January 1901, again

at the Savoy. Famously during this period, he watched the funeral procession of Queen Victoria with the American artist John Singer Sargent and novelist Henry James, and he visited an exhibition of Impressionist painting organized by Durand-Ruel at the Hanover Gallery, including his own work. He was not impressed by it, commenting, 'what a terrible way to try and get us known in this country.' The simultaneous series were mostly completed during the winter of 1902–3 back at Giverny (as the piece on page 73 is signed and dated). He worked on some as late as April 1903, but became frustrated with them and destroyed some. In all, Monet painted 85 London views. Of these, 37 went on display at Durand-Ruel's gallery in May 1904 in the exhibition 'Views of the Thames', with a catalogue written by Mirbeau. Durand-Ruel had purchased the works at 10,000–11,000 francs each, but sales were good and some fetched double the amount he had paid for them. The exhibition was a critical success and was extended by several days due to public demand.

Monet found inspiration for a further series of architecturally inspired works, painting in Venice in the autumn of 1908 and returning to complete the series in 1909. He depicted famous scenes such as the Palladian church of San Giorgio Maggiore at various times of day, the Grand Canal and the Palazzo Dario (see pages 6–7). However, despite this enjoyable sojourn, his major focus for inspiration during his later career was undoubtedly his Giverny garden and a series of waterlily paintings.

The Houses of Parliament, London, *1904. Parliament emerges as a ghostly impression in this painting, while the sky and water are painted in vibrant oranges and reds.*

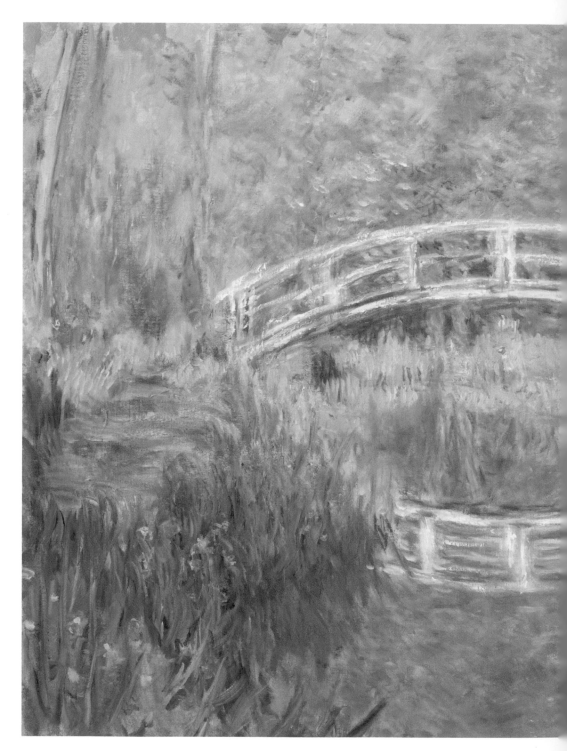

Japanese Footbridge, Giverny, *1895. This bridge became an enduring motif for Monet during the last 30 years of his life. Seen here in early summer, the garden is looking at its best, filled with flowers (including yellow irises) and with the trees in full leaf.*

CHAPTER 6
Giverny and the Waterlilies

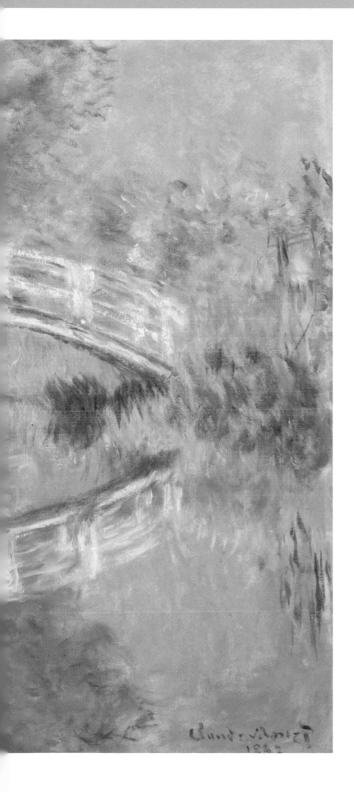

Family life at Giverny blossomed. The farmhouse and surrounding garden gradually became a major project. Monet had initially lovingly planned, planted and tended the grounds, assisted by the children. Following the death of her husband Ernest Hoschedé in 1891, Alice agreed to marry Monet, and they finally normalized their longstanding relationship in 1892. Although there was a studio at the western end of the house, eventually a second, larger, two-storeyed studio was built, to the north-west of the property. Increasingly Monet's presence in the village was making an impact: initially a trickle of mostly American artists came to pay homage, beginning with the arrival of Theodore Robinson, but this escalated so much during the 1890s that a hotel was established to accommodate the visitors. One of Monet's step-daughters, Suzanne, actually married an American artist, Theodore Earl Butler. Following her premature death in 1899, he married her older sister, Marthe.

Among Monet's many house guests were some of the most famous artists of the day, including Sisley, Pissarro and Cézanne, as well the American John Singer Sargent, who visited every summer from 1885 to 1889. Also visiting were Jacques-Émile Blanche, Pierre Bonnard, Paul Signac and his long-time admirer André Barbier. Monet's own collection of art was housed in his private rooms, so guests rarely had the opportuniy to view it. He owned paintings by Corot, Delacroix, Boudin and Jongkind, the latter two of whom influenced his work strongly early on. He also owned works by Cézanne, Pissarro and his friend Renoir, including nudes and *La Mosquée, fête arabe*, which he purchased from Durand-Ruel for 10,000 francs. After Alice died in 1911, Monet bought Carolus-Duran's portrait of her for himself.

Visitors were less frequent during World War I, but Clemenceau regularly called en route to his tours of the front line. Monet could hear the gunfire as he painted in the garden but refused to relocate. After the war, more distinguished guests came, including the 20-year-old Crown Prince Hirohito of Japan in 1921 and the wealthy Japanese industrialist Kōjirō Matsukata, who purchased 15 paintings for his proposed idea of a Museum of Western Art.

Claude Monet on the Japanese bridge in his garden at Giverny, c. 1920.

DEVELOPING THE GARDENS AT GIVERNY

In 1893, Monet acquired an adjacent meadow with a pond on the south side of the farmhouse, separated from it by a single-track railway line and dirt track. This he intended to develop as further water gardens. In March, he wrote to the local authorities of Eure about redirecting the River Ru (in actuality more of a stream-sized tributary of the River Epte), explaining that he wanted to create ponds on his new land, to the south of his existing garden, for the 'pleasure of the eye and for the motifs to paint'. This was no small undertaking: he needed not only to divert the river but also to introduce a system of sluices. Some local residents were unsure about the disruption of the waterflow and the introduction of new plants to the area. He was initially turned down, though permission was granted in late July on appeal.

Monet began immediately on the construction of the ponds and his new vision for that plot of land, planting trees such as weeping willows and Japanese tree peonies, and installing a Japanese-style wooden bridge in 1895, which became such a famous motif in later works. He enlarged the pond in 1901–2, increasing it to three times its original

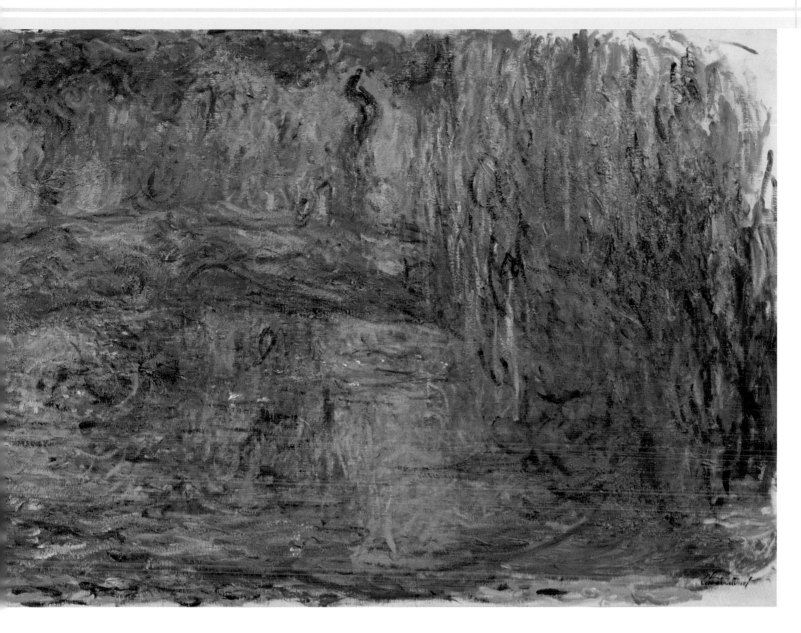

size, and made it larger still in 1910, to give more room for the cultivation of his beloved waterlilies. Four more footbridges were added to the garden complex in 1902 and an artificial island created. Monet also requested that his gardeners thin out the waterlilies, to create small clusters of pads, allowing more water to be seen. He cultivated friendships with horticulturists and visited other gardens for inspiration, and supervised much of the work himself. To begin with, he also tended much of the garden, but gradually found it necessary to employ a full-time head gardener, Félix Breuil, and five assistants. The flowers were spectacular, including climbing roses, irises and agapanthus, and alongside the abundant wisteria these created a riot of colour. Flowering shrubs from Japan were also planted, such as bamboo (planted around the ponds in 1906) and Japanese apricots. He later wrote, 'I have the deepest admiration for Japanese art and a great sympathy for the Japanese,' but he maintained that this was not a Japanese garden as such since there were many local varieties of plants growing. Over time, tropical varieties of waterlily were planted, which were red, copper and purple (and had to be removed and protected in the greenhouses over winter). But Monet's gardens needed to mature before he could begin to find inspiration in them.

The Japanese Bridge, Giverny, 1918. In later years, Monet suffered from a cataract problem that altered his perception of colour. This later view of the Japanese bridge in his garden appears almost to merge the bridge with the surrounding foliage and water in a very organic way.

THE JAPANESE FOOTBRIDGE

Monet was drawn to paint his new footbridge even before his waterlilies were established in its pond, though irises were visible at the sides of the water by 1895 (see pages 76–7). As the garden grew and matured and the waterlilies thrived, so he was drawn again to the subject in 1899, capturing the bridge in 17 canvases, observing it at different times of day and using again the square format. The bridge in *The Water-Lily Pond* (see page 11) is observed from the outflow of the pond, giving a low vantage point with no sky to be seen in the composition. This is a harmonized waterscape, of green tonality, immersing the viewer in Monet's very own personal garden, and such works pay tribute to his admiration for Japanese prints, especially Hokusai, who often depicted bridges, such as *Under the Mannen Bridge at Fukagawa* (1823). A series of Monet's harmonious Japanese bridge paintings was shown by Durand-Ruel in Paris the following year. Monet returned to the theme of the Japanese bridge in his art from 1918 onwards, but by then the original bridge itself had been transformed by the growing vegetation that engulfed it and Monet's style had also significantly changed, following his later struggle with his eyesight and cataracts (see pages 78–9).

THE WATERLILIES SERIES

The lush paradise of a garden he had created with cascading boughs and bright flowers continued to inspire Monet more generally at the turn of the century, as illustrated in the light-dappled surface of the shady path shown in *Pathway in Monet's Garden, Giverny* of 1902, but from 1903 onwards he developed a new focus at Giverny, a very specific concentration on his beloved waterlilies that lasted until the end of his life.

With the new layout of his water garden established in 1902, and his waterlilies flourishing, Monet began a new approach to painting these plants the following year. He eliminated the bridge itself from the composition and set his easel up early each morning on the Japanese bridge itself, adopting a viewpoint looking across the water surface. In the first works, Monet often included the edges of the pond, or the reflections of trees on the bank, sometimes capturing the sky and clouds as well. The real and reflected worlds feel as one in these integrated canvases, echoing each other, but the focus is not yet entirely on the waterlilies themselves.

Monet insisted on clear water in the ponds and the careful maintenance of the clusters of lilies (see page 82). One gardener was dedicated full-time to the maintenance of the waterlily garden to facilitate Monet's painting of it. Rowing in a small boat, the gardener would remove moss, algae and water grasses for Monet, to give clarity to the water.

Garden Path at Giverny, 1902.
This view shows the path leading
up to the main house at Giverny.
Additional small paths ran
along either side of this one, also
overflowing with flowers.

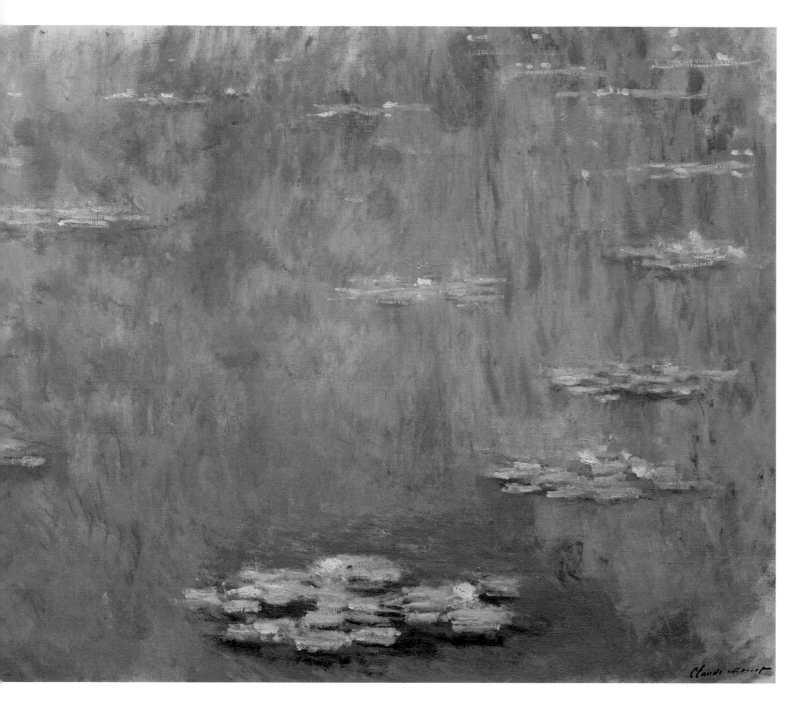

Waterlilies, *1903*.
In between the
waterlilies, the
deep-blue sky
is reflected in
the always-clear
water together
with nearby
overhanging
willows.

The waterlilies were inspected daily, fertilized at their roots and any dead blossoms and leaves meticulously removed. The remaining leaves were washed, as they collected dust from the nearby track. Eventually, Monet paid for the dirt track to be improved so that the dust would no longer disturb his plants, but he always regretted the historical chances that meant the track and railway divided his property as they did.

As he moved on from the London series, Monet began to focus more attention on the *Waterlilies* series. He continued to refine the compositions, shifting viewpoints and experimenting with the relative proportions of water, bank and sky. He often used drawings in his sketchbooks to help him with basic placement and composition outlines. The drawings of waterlilies are the most abstract. By 1905, he was concentrating on a smaller number

of waterlily pads, eliminating the bank altogether. He also increased the size of canvases and created a nearly square format, as can be seen on page 85. The 1906 paintings are much looser in handling than previously, and the lily pads seem quickly sketched. Gradually, Monet began to paint his waterlilies looking down more directly on to the water surface from the bridge, eliminating not merely the bank but normal perspective too, setting his angle of vision nearer the water surface and creating a more decorative treatment of it. Here the viewpoint is high, but it rises even more vertically in a second work (see page 86). With its blue and

green tones, this painting has a slightly mystical sense of space and solitude reminiscent of oriental art, reminding us that his studio was filled with portfolios of Japanese flower prints by Hokusai and others, many pasted to the walls.

Increasingly, Monet's approach to his waterlily painting became more abstract and obsessive.

Water Lilies, the Cloud, *1903. Rolling clouds are reflected in the water in this tranquil view of the lily pond, with just a hint of bank included. Monet and his family had by now been living at Giverny for almost 10 years.*

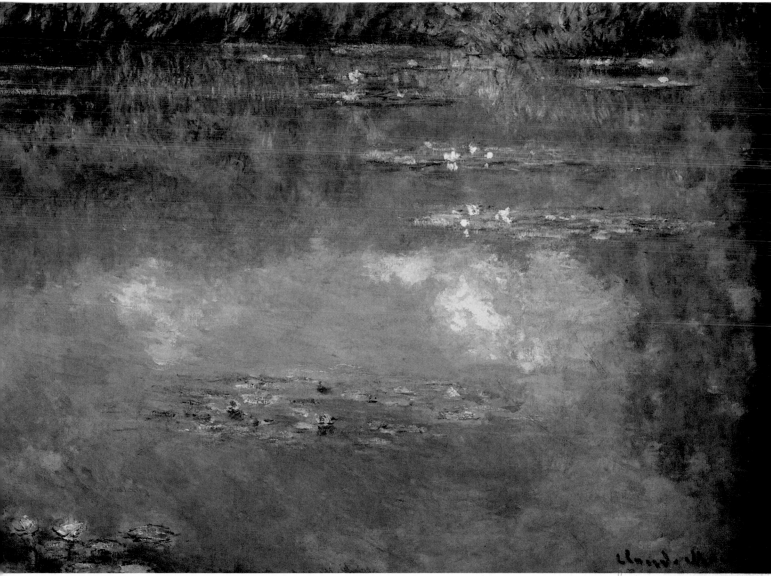

He informed Durand-Ruel, who was pressing him for work at one point, that he had 'destroyed at least 30 of these paintings'. He seems to have been particularly concerned about the integrity of the entire series and how it would hang together. He wrote to his friend the art critic Geffroy in 1908, 'You should know I am immersed in work. These landscapes of water and reflection have become my obsession. It is beyond my old man's strength, yet I still want to convey what I feel. I have destroyed some and then I start again afresh.' Technical examination of some works in this *Waterlilies* series indicates that he approached them over several sessions, reworking them and superimposing layer upon layer of brushstrokes and changing his mind about compositional elements.

Planning for an exhibition of these waterlily paintings began in 1907, but Monet's perfectionism meant that it did not come to fruition until May 1909, when Durand-Ruel showed 48 paintings from the series in three rooms of his Paris gallery. The exhibition was entitled '*Les nymphéas, series de paysages d'eau*' ('Water Lilies: Series of Water Landscapes'). Only one of the 1903 paintings made it through to the final selection; five paintings from 1904; 17 dated between 1905 and 1907, including 14 of the more vertical format; and eight from 1908. Monet also included some experimental circular canvases, and such was the anticipation that a number of works were sold even before the exhibition opened. It was a huge critical success. The subtle fusion of reality and reflection was commented upon, many comparing his waterlily paintings to poetry and music. Romain Rollard, Remy de Gourmont, Lucien Descaves and Claude Roger Marx were all immensely enthusiastic. Geffroy sent Monet his review for *La Justice* and Monet replied thanking him: 'You are always the one who says best whatever there is to say, and it is always a pleasure for me to be praised by you.' Rollard also wrote to Monet directly: 'I admire you most of all among today's artists,' he gushed. 'I need only turn to painting, where works like your waterlilies are blossoming, to reconcile myself with the art of our time and to believe that it stands comparison with the greatest that has gone before.'

Monet's work was now appreciated beyond France, particularly by the Americans and as far afield as Russia. Sarah Choate Sears of Boston was one of the earliest buyers at the exhibition. *Waterlilies*, 1908, did not sell at the show and was purchased by Durand-Ruel just afterwards, but it was resold a few years later to Gwendoline Davies in 1915, while she was serving with the Red Cross canteens. It joined her two other waterlily paintings, bought in 1913 from the Bernheim Jeune gallery, which reflects her and her sister Margaret's pioneering taste in buying such paintings in Britain.

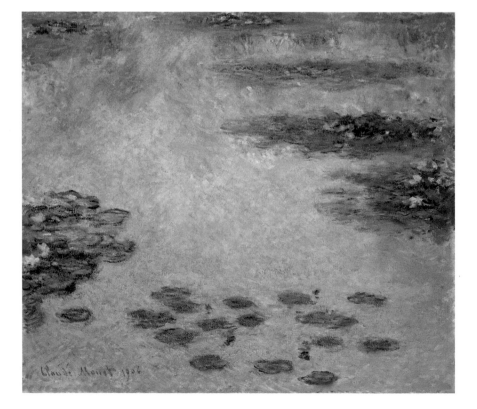

Waterlilies, 1906. More abstract in style than some of Monet's earlier studies of waterlilies, this view focuses on the plants and the water and makes no use of any physical structure, such as the bank of the pond, to create the perspective.

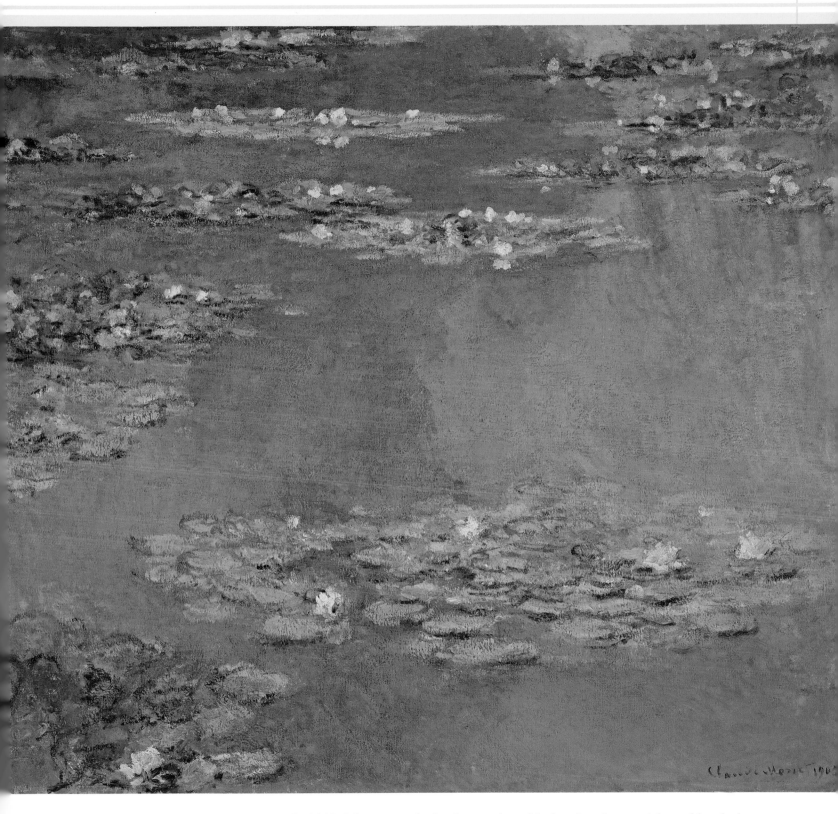

Water Lilies, 1905. Although the palette of colours is quite strong in this work, the brushwork is actually very soft and the viewer is almost at surface level with the lilies and the water, fully immersed in the scene.

In 1909, Monet consulted a doctor about his deteriorating eyesight and headaches. In a letter to Geffroy at the end of the year, he confided that he had not actually painted for many months, due to bad weather and his headaches. Early in 1910 his beloved wife Alice was diagnosed with leukaemia and she died the following year. Although devastated by her loss, Monet agreed to an exhibition of his Venice paintings in 1912. He continued to struggle with his eyesight and underwent the first of several painful

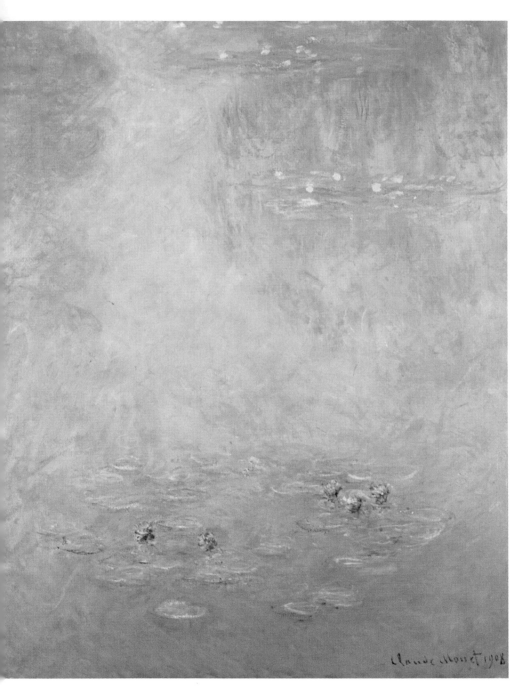

Waterlilies, 1908. 'These landscapes of water and reflection have become an obsession. They are beyond the powers of an old man, and yet I want to succeed in rendering what I perceive', Monet wrote in 1908, the year he painted this work capturing the suffused light reflected on his pond in a harmony of blues, violets and greens, highlighted by the pink and yellow flowers of the waterlilies themselves.

and debilitating cataract operations that year. He had painted little since Alice's death, but following the further loss of his eldest son Jean, who suffered an agonizing death in early 1914, Monet returned to his studio. There he began painting again, but on a much larger scale. In fact, a new top-lit studio had to be built in 1915 to accommodate the sheer size of canvases he now wanted to use. He seems to have had a temporary reprieve with his eyesight at this time: 'Up at four, I struggle all day, and by evening, I am completely exhausted. . . . My sight is fine again.' But soon the horrors of war were impacting on family life. Monet's step-son Jean-Pierre Hoschedé was called up to the transport corps and Michel, although declared unfit for active service, volunteered and saw service at Verdun.

Monet produced some of his greatest waterlily paintings even as the war raged about him and while he was still grieving for Alice and Jean. He concentrated on reproducing the shimmering surface of the waterlily ponds he had created, working in the winter months on large-scale canvases in his new studio. As the war drew to an end, the fighting came ever closer to Giverny, but Monet refused to move, saying that he would prefer to die in his studio. After the armistice was signed on 11 November 1918, he decided to donate some of his huge panels to the nation to mark France's victory.

Increasingly alone and suffering with his eyesight, he still found inspiration in his garden and was driven to complete a circular series of decorative paintings to create a massive panoramic frieze. This final great act confirms the breadth of his achievements. The panels were all the same height (1.97 metres/6½ feet) but differed in length so that they could be hung across the curved walls of two egg-shaped rooms. Monet worked closely with the architect Camille Lefèvre and received continual encouragement from Clemenceau. The whole set is one of the most monumental creations in painting made in the first half of the twentieth

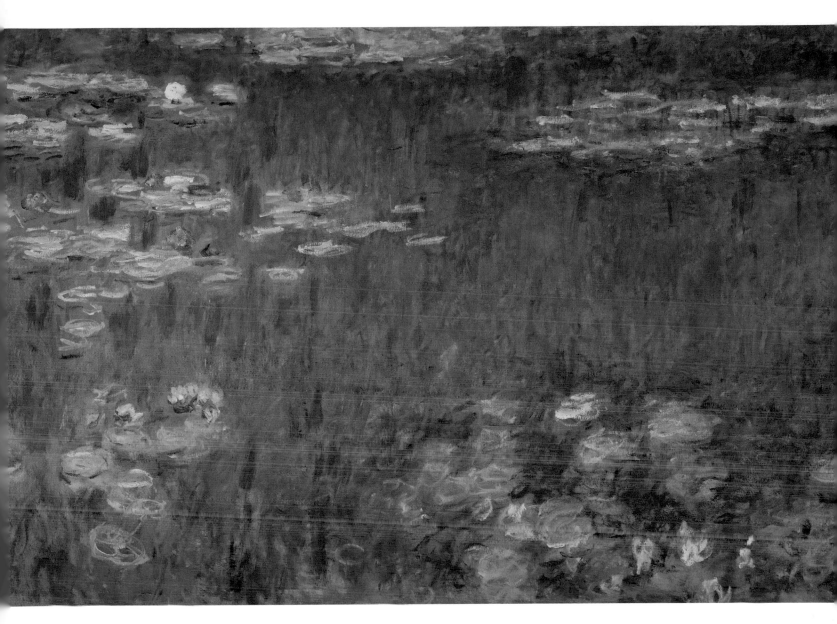

century and covers a surface area of 200 square metres (2,150 square feet). Monet wrote that he wanted to create 'the illusion of an endless whole, of a wave with no horizon and no shore'.

The gift was organized through his friendship with Georges Clemenceau, the prime minister of France from 1917 to 1920. The negotiations were protracted and Monet refused to deliver the works during his lifetime. Now old and frail, he was cared for at Giverny by Blanche Hoschedé-Monet, widow of his son Jean, but still he worked on. 'I am working as never before, I am happy with what I am doing,' he wrote to the younger French artist and admirer André Barbier in July 1915. This was the greatest final effort for him, to ensure that they were complete. Aged 86, Monet died on 5 December 1926. The waterlily paintings, known as his *grandes décorations*, opened in the Orangerie in the Tuileries garden in Paris in May 1927, a permanent

Waterlilies: Green Reflections *(left section), 1914–18. Part of one of the* grandes décorations, *the work's dark blue and green tones contrast with the brightness of the waterlilies, while the swirling brushwork draws the viewer into the depths of the water.*

legacy for the French State. But Impressionism was not as popular as it had been and Monet had outlived his contemporaries – Sisley had died in 1899, Pissaro in 1903 and Renoir in 1919. Cubism then Surrealism were the dominant art movements in Paris, and Impressionism seemed to some outdated. Given Monet's universal popularity today, it comes as some surprise to learn that his late paintings given to the nation were not immediately popular with the public. Indeed, the assistant curator responsible at the Orangerie, Robert Rey, commented, 'For me this period is no longer Impressionism, but its decline.' Clemenceau himself, visiting a year after the opening, lamented on 7 June 1928, 'Yesterday I went to the Orangerie . . . there was no one else there at all.' Fellow artists were also not entirely supportive either, with Jacques-Émile Blanche, once an admirer of Monet's, writing in *L'Art Vivant* in September 1927, 'These spots,

Water Lilies
 The Clouds
(central section),
1915–26. There
is a meditative
quality about the
series of canvases
that now hang
in the Musée
de l'Orangerie,
none more
so than this
depiction of
clouds reflected
in the water.

these splashes, these scratches inflicted on the surface of canvases of who knows how many square metres . . . a theatrical set designer with his bag of tricks could succeed in producing much the same effect.'

Visitors complained that it was often too dark to see the canvases and sometimes other exhibits, such as tapestries, were hung in front of these huge waterlily compositions, obstructing them completely. By the late 1930s it was one of the least visited museums in Paris. The roof of one room was damaged during the World War II bombings of Paris in 1944, and one of the compositions had to be restored, though the other panels remained miraculously unharmed. After the war, there was a revival of interest in Monet generally and in the late waterlily paintings in particular, led by American artists.

EPILOGUE: MONET'S LEGACY AND INFLUENCE

Monet's popularity in America ensured that a whole generation of artists adapted Impressionist approaches to their paintings of American landscapes, including Childe Hassam, John Leslie Breck, William Merritt Chase, Willard Metcalf and John Henry Twachtman, as well as artists drawn to contemporary life in urban settings such as William Glackens and Maurice Prendergast. Childe Hassam's *Isle of Shoals* paintings are an overt tribute to Monet's seascapes. However, it was Monet's late great series of large-scale waterlily paintings, so abstract and yet so energetic and painterly, which are often seen as having greater impact on America's Abstract Expressionists in the 1950s. They rediscovered Monet's late waterlily paintings after the Surrealist painter Andre Masson published on this series of works in 1952 and the Museum of Modern Art (MOMA) acquired and displayed a late waterlily canvas in 1955, the first public institution in the United States to acquire one from this series. Interestingly, Monet had not featured in the early collecting at MOMA, which opened in 1929, but this was addressed in the 1950s, although there was a setback in April 1958 when fire destroyed two of the museum's waterlily paintings. There was an incredible public reaction to the loss of the works, and in the following year, the museum's director purchased the famous triptych of waterlilies from the artist's son Michel Monet.

Jackson Pollock, Ellsworth Kelly, Helen Frankenthaler, Mark Rothko, Joan Mitchell, Mark Tobey and John Paul Riopelle continued many of Monet's obsessions with size and fluid painterly surfaces. It is important not to overstate the connection but, in 1955, Clement Greenberg in his *American-type Painting* pointed out the obvious similarities

Surf, Isles of Shoals, *Childe Hassam, 1913. One of the leading American Impressionists, Hassam depicts the coastline near Portsmouth in New Hampshire in the United States. The brushwork, use of colour and choice of motif are all reminiscent of Monet's fascination with rock formations and the play of light on water.*

between the late work of Monet and that of painters like Jackson Pollock, Clyfford Still and Barnett Newman. Then the art critic Louis Finkelstein in 1956 emphasized the clear connection between Monet's late work and these artists by using a new term of reference for them, the 'Abstract Impressionists'. Monet might have been long dead, but his influence on young artists, on popular culture and on collecting grew from strength to strength. MOMA redisplayed all of its waterlily paintings in 2004 when it reopened after redevelopment, and celebrated the waterlilies again in 2009 with a dedicated loan exhibition. Back in France, at the Musée de l'Orangerie, a 2006 renovation of the space returned it to its original state, building work in the 1960s having obstructed the natural light from above which Monet had so desired. More recently, as part of the World War I commemorations in 2018–19, the museum emphasized that these gigantic decorative panels were given to France as a symbol of victory following the war, negotiated through the efforts of Georges Clemenceau. The paintings remain the greatest tribute to a long and illustrious career.

Number One, 1950 (Lavender Mist), Jackson Pollock, 1950. The Abstract Expressionist was indirectly influenced by the later works of Monet, using large canvases and aiming to create a sense of being immersed in the image as he created it.

TIMELINE

1840s

'40 Claude Monet is born in Paris.

'45 The Monet family moves to Le Havre.

1850s

'55 Begins making graphite caricatures of local figures.

'57 Death of Monet's mother

'58 *View from Rouelles* is exhibited in the Le Havre municipal exhibition.

1860s

'61 Called up for military service in Algeria.

'62 Enrols at the Académie Atelier under the tutelage of Charles Gleyre.

'65 Paints *Le déjeuner sur l'herbe*

'67 Monet's son Jean is born.

'69 Paints *La Grenouillère* while working with Renoir.

1870s

'70 *Luncheon* and *La Grenouillère* rejected by the Paris Salon.

'70–71 The Franco-Prussian War takes place and Monet and his family move to London.

'71 Moves to Argenteuil, and he meets the art dealer Paul Durand-Ruel, beginning a long friendship.

'72 Paints *Impression, Sunrise*, which gave the impressionist movement its name.

'72–73 Begins painting images from his garden at Argenteuil.

'73 The *Société anonyme des artistes, peintres, sculpteurs et graveurs* is officially launched.

'74 The First Impressionist Exhibition is held in Paris, displaying the work of Monet, Degas, Renoir and others.

'77 Completes his paintings of the *Gare Saint-Lazare*.

'78 Returns to Paris with his family. The Exposition Universelle opens.

'79 His wife Camille dies.

1880s

'83 Moves to Giverny.

'86 Paints *The Rocks at Belle-Île.*

'89 Raises funds to buy Manet's *Olympia* and donates the painting to the Louvre Museum.

1890s

'90 Begins painting *The Grainstacks* series.

'91 Begins painting *The Poplar* series.

'92 Marries Alice Hoschedé. Begins painting *Rouen Cathedral* series.

'99 Paints *The Thames at Charing Cross Bridge.*

1900s

'00 Begins painting *The Houses of Parliament* series.

'00s Visits Venice and produces a number of views of the city.

'03 Begins painting the *Waterlilies* series using the inspiration of his water garden at Giverny.

1910s

'11 Death of Monet's second wife, Alice.

'14-18 World War I. Monet's son Michel works as an ambulance volunteer.

1920s

'21 Crown Prince Hirohito of Japan visits Monet at Giverny.

'26 Monet dies from lung cancer on 5 December and is buried at Giverny.

FURTHER INFORMATION

Bomford D, Kirby J, Leighton, J., Roy A., *Art in the Making: Impressionism*, National Gallery Publications, London, 1990, pp. 120–5.

Brettell, Richard R, *Impressionism: Painting Quickly in France 1860–1890*, Sterling and Francine Clark Art Institute, Williamstown, 2000

Don, Monty & Dumas, Ann, *Painting the Modern Garden: Monet to Matisse*, Royal Academy, London, 2015

Fowle, F (ed), *Monet and French Landscale Vétheuil and Normandy*, National Galleries of Scotland, Edinburgh, 2006

Ganz, James A, *The Unknown Monet: Pastels and Drawings*, Sterling and Francine Clark Art Institute, Williamstown, 2007

Patry, Sylvie (ed), *Inventing Impressionism: Paul Durand-Ruel and the Modern Art Market*, National Gallery London, 2015

Temkin, Ann & Lawrence, Nora, *Monet: Water Lilies* (MoMA Artist Series), The Museum of Modern Art, New York, 2009

Thompson, Richard, *Monet, the Seine and the Sea*, National Galleries of Scotland, Edinburgh, 1999

Thompson, Richard, *Monet and Architecture*, National Gallery, London, 2018

Tucker, Paul Hayes, *Monet: Life and Art*, Yale University Press, London, 1995

Tucker, Paul Hayes, *The Impressionists at Argenteuil*, Yale University Press, London, 2000

Wildenstein, Daniel, *Claude Monet. Biographie et catalogue raisonné*, La Bibliothèque des Arts, Fondation Wildenstein, Lausanne, Paris, 1974

Wildenstein, Daniel, *Monet, The Triumph of Impressionism*, Taschen, Cologne, 2010

Wilson, M., Wyld, M., Roy, A., *Monet's Bathers at La Grenouillère*. National Gallery Technical Bulletin Vol 5, p. 14, London, 1981

WEBSITES

Art Institute, Chicago – artic.edu

Fondation-monet.com (The Fondation Claude Monet, Giverny, France)

Metropolitan Museum of Art, New York – metmuseum.org

Musée Marmottan Monet, Paris – marmottan.fr

Musée de l'Orangerie, Paris – musee-orangerie.fr

Musée d'Orsay, Paris – musee-orsay.fr

Museum of Fine Arts, Boston, Massachusetts, USA – mfa.org

National Gallery, London – nationalgallery.org.uk

LIST OF ILLUSTRATIONS

Page 6
Venice, Palazzo Dario, 1908, oil on canvas, 66.2 × 81.8 cm (26 × 32¼ in), Art Institute of Chicago, Chicago, USA. Mr and Mrs Lewis Larned Coburn Memorial Collection.

Page 8
Impression, Sunrise (Impression, soleil levant), 1872, oil on canvas, 48 × 63 cm (19 × 24¼ in), Musée Marmottan Monet, Paris, France. AKG Images.

Page 10
EQRoy/Shutterstock.

Page 11
The Water-Lily Pond, 1899, oil on canvas, 88.3 × 93.1 cm (34¾ × 36½ in), National Gallery, London, United Kingdom. Bridgeman Images.

Page 12, top
Nymphéas, 1918, pencil on blue-grey payer, 31.5 × 47.5 cm (12½ × 18¾ in), Musée Marmottan Monet, Paris, France. AKG Images.

Page 12, bottom
Waterloo Bridge, 1901, pastel, 31.1 × 50.2 cm (12¼ × 19¾ in), National Gallery of Art, Washington DC, USA. AKG Images.

Page 13
Bridgeman Images.

Page 14
Claude Monet Reading a Newspaper, Auguste Renoir, 1872, oil on canvas, 61 × 50 cm (24 × 19½ in), Musée Marmottan Monet, Paris France. Bridgeman Images.

Page 15
Caricature of Auguste Vacquerie, c. 1859, graphite on tan wove paper, 28.4 × 17.6 cm (11¼ × 7 in), Art Institute of Chicago, Chicago, USA. Collection of Mr and Mrs Carter H. Harrison.

Page 16
View at Rouelles, 1858, oil on canvas, 46 × 65 cm (18 × 25½ in), Private Collection. Bridgeman Images.

Page 17
The Beach at Trouville – The Empress Eugénie, Eugène Louis Boudin, 1868, oil on panel, 34.2 × 57.8 cm (13½ × 22¾ in), Burrell Collection, Glasgow, Scotland. CSG CIC Glasgow Museums Collection/Bridgeman Images.

Page 18
Caricature of Léon Manchon, c. 1858, charcoal on blue laid paper, 61.2 × 45.2 cm (24 × 17¾ in), Art Institute of Chicago, Chicago, USA. Collection of Mr and Mrs Carter H. Harrison.

Page 19
Étretat, Johan Barthold Jongkind, 1865, oil on canvas, Private Collection. Bridgeman Images.

Page 21
The Improvised Field Hospital (L'ambulance improvisée), Frédéric Bazille, 1865, oil on canvas, 47 × 62 cm (18½ × 24½ in) Musée d'Orsay, Paris, France. Bridgeman Images.

Page 22
La Pointe de la Hève at Low Tide, 1865, oil on canvas, 90.2 × 150.5 cm (35½ in × 59¼ in), Kimbell Art Museum, Fort Worth, USA. AKG Images.

Page 23
Le déjeuner sur l'herbe, 1865–6, oil on canvas, 248 × 217 cm (97½ × 85½ in), Musée d'Orsay, Paris, France. AKG Images.

Page 24
Camille (The Woman in the Green Dress), 1866, oil on canvas, 231 × 151 cm (91 × 59½ in), Kunsthalle, Bremen, Germany. De Agostini Picture Library/AKG Images.

Page 25
Women in the Garden, 1866–7, oil on canvas, 255 × 205 cm (100½ × 80¾ in), Musée d'Orsay, Paris, France. Bridgeman Images.

Page 26
Madame Louis Joachim Gaudibert, 1868, oil on canvas, 217 × 138.5 cm (85½ × 54½ in), Musée d'Orsay, Paris, France. Erich Lessing/AKG Images.

Page 27, top
Garden at Sainte-Adresse, 1867, oil on canvas, 98.1 × 129.9 cm (38½ × 51 in) , Metropolitan Museum of Art, New York, USA. AKG Images.

Page 27, bottom
The Magpie, 1869, oil on canvas, 89 × 130 cm (35 × 51¼ in), Musée d'Orsay, Paris France. Album/AKG Images.

Page 28, top
The Artist's Studio, Jean Frédéric Bazille, 1870, oil on canvas, 98 × 128.5 cm (38½ × 50½ in), Musée d'Orsay, Paris, France. Bridgeman Images.

Page 28, bottom
La Grenouillère, 1869, oil on canvas, 74.6 × 88.7 cm (29½ × 35 in), Metropolitan Museum of Art, New York, USA. Bridgeman Images.

Page 29
La Grenouillère, Auguste Renoir, 1869, oil on canvas, 66 × 81 cm (26 × 32 in), National Museum, Stockholm, Sweden. AKG Images.

Page 30
Hôtel des roches noires. Trouville, 1870, oil on canvas, 81 × 58.5 cm (32 × 23 in), Musée d'Orsay, Paris France. Hervé Champollion/AKG Images.

Page 31, top
On the Beach at Trouville, 1870, oil on canvas, 38 × 46 cm (15 × 18 in), Musée Marmottan Monet, Paris, France. Bridgeman Images.

Page 31, bottom
The Beach at Trouville, 1870, oil on canvas, 37.5 × 45.7 cm (14¾ × 18 in), National Gallery, London, United Kingdom. AKG Images.

Page 32
Green Park, London, 1870/71, oil on canvas, 34.3 × 72.5 cm (13½ × 28½ in), Museum of Art, Philadelphia, USA. AKG Images.

Page 33, top
The Thames at London, 1871, oil on canvas, 48.5 × 74.5 cm (19 × 29¼ in), National Museum of Wales, Cardiff, United Kingdom. Heritage Images/ National Museum of Wales/AKG Images.

Page 33, bottom
Meditation, Madame Monet Sitting on a Sofa (Madame Monet au canape), 1871, oil on canvas, 58 × 75 cm (23 × 29½ in), Musée d'Orsay, Erich Lessing/AKG Images.

Page 34
The Marina at Argenteuil, 1872, oil on canvas, 80.5 × 60 cm (31¾ × 23½ in), Musée d'Orsay, Paris, France. Heritage Images/Art Media/AKG Images.

Page 36, top
Lilacs, Grey Weather, 1872, oil on canvas, 50 × 65.5 cm (19¾ × 25¾ in), Musée d'Orsay, Paris France. Laurent Lecat/AKG Images.

Page 36, bottom
The Artist's House at Argenteuil, 1873, oil on canvas, 60.2 × 73.3 cm (23¾ × 29 in), Art Institute of Chicago, Chicago, USA. Collection of Mr and Mrs Martin A. Ryerson.

Page 37
Poppy Field, 1873, oil on canvas, 50 × 65 cm (19¾ × 25¾ in), Musée d'Orsay, Paris, France. Bridgeman Images.

Page 38
The Promenade at Argenteuil, 1872, oil on canvas, 53 × 73 cm (21 × 28¾ in), Private Collection. Sotheby's/AKG Images.

Page 39
Boulevard des Capucines, 1873, oil on canvas, 61 × 80 (24 × 31½ in), Pushkin State Museum of Fine Arts, Moscow, Russia. AKG Images.

Page 40
The Bridge at Argenteuil, 1874, oil on canvas, 60 × 79.7 cm (23½ × 31½ in), National Gallery of Art, Washington DC, USA. AKG Images.

Page 41
Landscape: The Parc Monceau, 1876, oil on canvas, 59.7 × 82.6 cm (23½ × 32½ in), Metropolitan Museum of Art, New York, USA. Liszt Collection/ AKG Images.

Page 42
View of the Tuileries Gardens, 1876, oil on canvas, 54 × 73 cm (21¼ × 28¾ in), Musée Marmottan Monet, Paris, France. AKG Images.

Page 43
La rue Montorgueil à Paris. Fête du 30 Juin 1878, 1878, oil on canvas, 81 × 50 cm (32 × 19¾ in), Musée d'Orsay, Paris, France. Hervé Champollion/ AKG Images.

Page 45
Rue Saint-Denis, Fête du 30 Juin 1878, 1878, oil on canvas, 74 × 102 cm (29 × 40 in), Musée des Beaux Arts, Rouen, France. G. Dagli Orti/De Agostini Picture Library/AKG Images.

Page 46
Le Pont de l'Europe, Gare Saint-Lazare, 1877, oil on canvas, 64 × 81 cm (25¼ × 32 in), Musée Marmottan Monet, Paris, France. Bridgeman Images.

Page 47, top
The Gare Saint-Lazare: Arrival of a Train, 1877, oil on canvas, 80.3 × 98.1 cm (31½ × 38½ in) Fogg Art Museum, Harvard Art Museums, USA. Bequest from the Collection of Maurice Wertheim, Class 1906/ Bridgeman Images.

Page 47, bottom
La Gare Saint-Lazare (on the suburban side), pencil on paper, 25.5 × 34 cm (10 × 13½ in), Musée Marmottan Monet, Paris, France. Bridgeman Images.

Page 48
The Thaw on the Seine, near Vétheuil, 1880, oil on canvas, 60 × 100 cm (23½ × 39½ in), Musée d'Orsay, Paris, France. Bridgeman Images.

Page 50
Camille Monet on her deathbed, 1879, oil on canvas, 90 × 68 cm (35½ × 26¾ in), Musée d'Orsay, Paris, France. G. Dagli Orti/De Agostini Picture Library/ AKG Images.

Page 51, top
The Seine at Lavacourt, 1880, oil on canvas, 98.4 × 149.2 cm (38¾ × 58¾ in), Dallas Museum of Art, Dallas, USA. Munger Fund/Bridgeman Images.

Page 51, bottom
The Road in Vetheuil in Winter, 1879, oil on canvas, 52.5 × 71.5 cm (20½ × 28 in), Göteborgs Konstmuseum, Göteborg, Sweden. De Agostini Picture Library/AKG Images.

Page 52, top
Cliffs near Fécamp, 1881, oil on canvas, 61 × 79 cm (24 × 31 in), Private Collection. Christie's Images/ Bridgeman Images.

Page 52, bottom
The Cliff Walk at Pourville, 1882, oil on canvas, 66.5 × 82.3 cm (26 × 32 ½ in), Art Institute of Chicago, Chicago, USA. Mr and Mrs Lewis Larned Coburn Memorial Collection.

Page 53
The Church at Varengeville, 1882, oil on canvas, 65 × 81 cm (25¾ × 32 in), Barber Institute of Fine Arts, University of Birmingham, United Kingdom. Bridgeman Images.

Page 54, top
The Manneporte, seen from Below, 1883, oil on canvas, 73 × 92 cm (28¾ × 36¼ in), Private Collection. Christie's Images/Bridgeman Images.

Page 54, bottom
By the River at Vernon, 1883, oil on canvas, Private Collection. Bridgeman Images.

Page 55
Garden in Bordighera, Impression of Morning, 1884, oil on canvas, 65.5 × 81.5 cm (25¾ × 32 in), State Hermitage Museum, St Petersburg, Russia. Bridgeman Images.

Page 56
The Rocks at Belle-Île, 1886, oil on canvas, 65 × 81 cm (25¾ × 32 in), Pushkin Museum, Moscow, Russia. Bridgeman Images.

Page 57, top
The Rocks at Belle-Île, the Wild Coast, 1886, oil on canvas, 65 × 81.5 cm (25¾ × 32 in), Musée d'Orsay, Paris, France. Bridgeman Images.

Page 57, bottom
In the Woods at Giverny: Blanche Hoschedé at Her Easel with Suzanne Hoschedé Reading, 1887, oil on canvas, 91.4 × 97.8 cm (36 × 38½ in), Los Angeles County Museum of Art, Los Angeles, USA. AKG Images.

Page 58
Tulip Fields in Holland, 1886, oil on canvas, 66 × 82 cm (26 × 32¼ in), Musée d'Orsay, Paris, France. Heritage Images/Fine Art Images/AKG Images.

INDEX